mindful sketching

mindful sketching

HOW TO DEVELOP A DRAWING PRACTICE
AND EMBRACE THE ART OF ~~PERFECTION~~ *imperfection*

PEGGY DEAN

SPRUCE BOOKS
A Sasquatch Books Imprint

embrace
imperfection

Contents

Foreword *vi*

Introduction: A Message to My Readers *ix*

THE FLIP SIDE OF MINDFULNESS **1**

MATERIALS **13**

SKETCHING WITH THE GOAL OF IMPERFECTION **17**

TECHNIQUES **33**

FRAMING A SCENE **67**

CAPTURING MOODS IN SKETCHES **81**

WHAT YOU SKETCH EVOKES EMOTION **87**

YOUR CHOSEN SUBJECT **95**

TECHNIQUES FOR SKETCHING PEOPLE **115**

SKETCHING PROMPTS **127**

REDEFINE COMPLETION **137**

Resources *147*

Acknowledgments *155*

Index *156*

Foreword

It's a true honor to have my friend Peggy Dean invite me to write this foreword. Peggy is a refreshingly real and much needed voice in the resurgence of on-location sketching across the globe, and its power to transform how we see and thus how we experience the world around us. The line she draws linking sketching to mindfulness (a term Peggy rightly replaces early on in this book with *awareness*) is at the heart of that transformation.

Though I've been drawing since preschool days, it was on-location sketching as a student of landscape architecture at Louisiana State University that first opened my eyes to drawing as more than doodling from memory or imagination. Indeed, sketching a place on location became a doorway to awareness, as it demands that we observe our subjects more closely. In doing so, we see them more clearly, and experience them more deeply.

This heightened awareness gives us fresh eyes with which to see the world. We become more aware of the particular natural features and characteristic vegetation of a place. We examine and sketch our interpretations of building materials, surface textures, patterns, light, and shadow. In turn, our senses become heightened to smells and sounds around us. We become more attuned to behavior—why people are frequenting a particular corner of a plaza, how they sit, how they cluster, what they are eating and drinking. Over time we gain insight into what makes some places lively magnets for activity while others are oases of quietude.

This doorway to awareness changes everything. Sketching becomes a way to be still, to go deep, and to begin to open a playful conversation between place, pen, and personality. The rewards are insights into an underlying spirit of place, whether the immediate subject is a landscape, a town, a group of nuns strolling down the sidewalk, or some memorable street food.

Peggy brings experience and empathy to this creative path. In this volume she shares hard won lessons regarding a range of sketching techniques that can save one many hours (even years) of frustratingly slow progress through trial and error. These lessons are necessary and valuable, but they are secondary to the wisdom she offers regarding foundational attitudes. Peggy has a gift for making people comfortable with their own experience and skill level, and with the idea of imperfection—that our sketches are not intended to be finished works of art so much as our own authentic reaction to what we are seeing. Rather than an end in itself, each sketch is seen as part of a continuum of documenting life experiences and learning along the way. You'll also find that it's a pleasurable form of meditation—a discipline that requires you be fully in the present moment.

We often hear that it's more about the path than the destination. What's not said as often is that the experience of the path can be much richer and more rewarding if you're traveling with someone who's been there before—someone who speaks the language, who knows where some of the potholes are, who can offer shortcuts when appropriate, and who is always there with an empathetic ear and an encouraging word. Peggy is a light on the path, a road-worthy guide. Enjoy your journey.

—JAMES RICHARDS

Introduction:

A Message to My Readers

I'm gonna give it to ya straight. I'm a human person with swirling thoughts that don't slow down, that demand attention and processing and building upon, and lead to even more thoughts that cause a feeling of overwhelm, and, and, and . . . So when the concept of mindfulness was first proposed to me, all I could think about were the pretty futile attempts I put in during the last ten minutes of yoga classes to just lie in silence and focus on my breathing. Some people are great at this, but me—well, I couldn't get out of there fast enough. It's hard for me to sit still and even harder to quiet my thoughts. I'm fidgety and feel the need for stimulation and constant movement. I know this isn't the way that everyone feels, but the reason I'm telling you this about myself is because I've always been so resistant to the idea of practicing mindfulness, yet now it's one of my favorite practices—and that means something. If I can do it, and if it changed my life for the better in such a huge way, best believe I want to shout it from the top of a mountain.

I've been through some heavy, dark stuff, as I'm sure you have in some way or another. In my teen years I developed some coping mechanisms that worked at that time but unfortunately, when carried into adulthood, turned into rather damaging behaviors. I'm going to go out on a vulnerable limb here and let you know that mental health has been a leading

factor throughout my life, showing up destructively, showing up help-lessly, always showing up to challenge me in some way. My first reaction was to put my head in the sand, which served only to turn me away from healthy solutions. I've felt a lot of shame around it, and with shame comes hiding. I ignored the negative feelings and put on a happy face and continued struggling despite what I thought were my best efforts. Little did I know, I had a lot of work and personal growth ahead of me.

There's a nasty stigma surrounding mental health, which is baffling con-sidering the fact that nobody even blinks when health affects our bodies instead of our minds. People talk about migraines or sciatica or high blood pressure and it's totally acceptable, even relatable. But if someone mentions a diagnosis of bipolar, borderline, or ADHD it immediately sends up the red flags. I call BS. We should take this opportunity to feel comfortable, even confident, while owning our truth. The more we can bring up these topics in a natural and organic way, the more we normal-ize them and the more we can support and advocate for our loved ones and even ourselves. Vulnerability is power. Vulnerability is bravery. So I'm showing up and I want to thank you for meeting me in this vulnerable space.

One of my favorite quotes, which I heard during what some might call a battle with mental health but I'll just call my journey, is this gem on the opposite page:

I highly recommend reading *The Power of Vulnerability* by Brené Brown, and it's even better on audiobook. Get ready to feel all the feels.

We cultivate love
when we allow
our most vulnerable
and most powerful
selves to be deeply seen
and known, and when
we honor the spiritual
connection that grows from
that offering with
trust, respect, kindness,
and affection.

- Brené Brown

When I was challenged to practice "mindfulness" to begin my healing process and redirect the way I responded to my emotions and triggers, I was quick to look the other way. That was, until I discovered my own version of mindfulness in the process. A version of mindfulness that didn't judge my inability to sort my thoughts into perfect little boxes. A version of mindfulness that didn't make me feel restless. A version of mindfulness that allowed me to create an entirely new life for myself as an artist and educator and as someone who can use the platform I've built to speak up, live out loud, and provide a space for people who share this creative passion to show up without filters, to feel wholly accepted, to know that their story matters and that there is a place for them. Because there is a place for you here. And my friend, your story matters.

A huge part of my experience in tuning in and learning more about self-discovery was my own blossoming creativity. I think of creativity like energy in my body that needs to come out as visual representation. It's not about the end result. Instead, it is the process of making something using my hands (and brain and heart), whether it be 3D or on paper, that is a wonderful way to channel my thoughts and calm my angsty mind. I think of creativity as a process that is both mindless and mindful—focusing our thoughts and efforts on a creative project allows us to release the day's stress, busyness, and worries, while we check in to something we can feel proud of. Something that we create with our own bodies. It's a beautiful thing.

Your self-expression is important and I'm going to take you through one of my favorite creative methods that embraces imperfections along the way. Get ready to connect with yourself!

Your story matters.

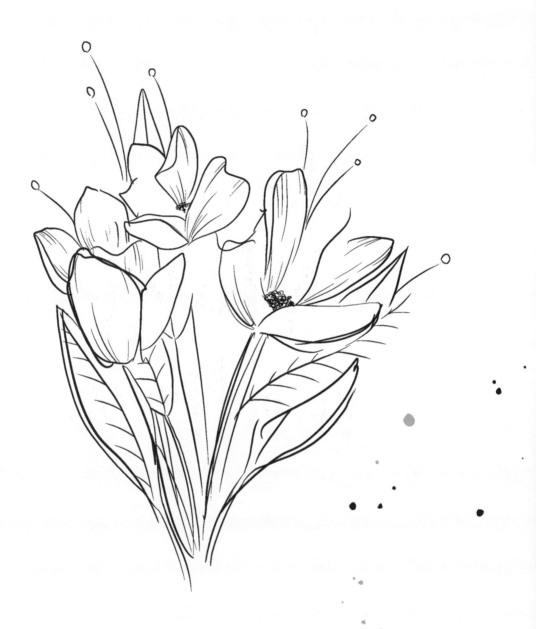

The Flip Side of Mindfulness

Spoiler alert: It's not so scary after all

Before we jump into creating together, allow me to take you through what I'll dub a "modern mindfulness experience" that won't make you want to roll your eyes. *Mindfulness* is a term that gets used (over-used?) so much that its meaning can get lost, so for the purposes of this discussion, I am going to call it *awareness* instead.

I've faced challenges with truly being aware of my behaviors, as I'm sure we all have. But taking a moment to feel our bodies in space and time can ground us and remind us to appreciate the life unfolding around us, the small moments of goodness, the conversations we connect with, the little but important things that get overridden by our digitally demanding world. While I can certainly appreciate the power of having knowledge at our fingertips, we mustn't let it distract us from the real life around us. The digital world can be suffocating; social media can lead us into a false sense of comparison and beliefs that are limiting. I want to give you the opportunity to set all of that noise aside for a while. We'll be connecting with this approach and practice throughout this book.

mindfulness

↓

awareness

If you think about it, so much of what we do is automatic. We are efficient beings who learn to multitask, which tends to make us disconnect from the here and now. Our minds control us, but it should be the other way around, don't you think? I'm sure I'm not the only one who pushes away negative feelings without even realizing I'm doing it. It makes sense—who wants to feel negative feelings? Acknowledging those feelings might bring deeper pain. It would mean that we might have to feel and confront our shame or sadness or anger or fear. Ignoring or suppressing negative feelings is a natural response.

No matter how connected we are, we all suppress emotions at some point. Sometimes we feel the need to put on a brave face and smile through it, fooling ourselves that not dealing with the issue or the emotions that accompanied it is a fine idea. That is, until those suppressed feelings manifest themselves in unpleasant or unexpected ways in our lives. We end up creating cycles of bad habits because it seems easier to avoid negativity. I'm willing to bet that at least half of the people who have experienced a panic attack in their lives have some issue in their past that they never properly dealt with. (*Raises hand:* Guilty.)

Let's face this thought for a moment: What if you allow yourself to feel a negative emotion? What if you discover that you can handle being temporarily annoyed, sad, or otherwise discomfited? What if you discover that when you just sit calmly with your feelings without trying to change anything it's not only okay, but you actually feel better? This is being mindful, and when you really do the work of being mindful you will find the bad feelings have something positive to give you. Just think about how relieved you feel when you finally get something off your chest that

you'd been avoiding talking about. It's an instant release and forges a deeper connection to yourself and to those you love. When we connect to the present moment and remove ourselves from our worried mind, it greatly mitigates negative effects of our stress response. We can regain our power to regulate our reactions and responses to the pressure of our day.

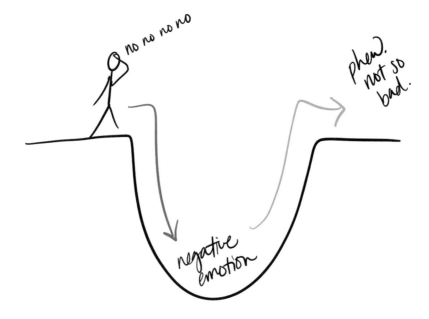

Think of emotions like this visual pitfall. You're moving forward in your journey when you encounter the interruption of a negative feeling. Since you're continuing to move forward, you also are going to pass through and come out the other side of that negative feeling. You do not have to drop into the pit of negativity and hang out there! You can simply keep on moving and accept that this is an experience along your path. There are two really helpful takeaways embedded in this seemingly simple image. The first is knowing that negative emotions are temporary and the second is that our triggers aren't going to trap us in a prison within our minds. When you accept that these things are true, you can take a huge step in moving forward (literally).

If you're anything like me (that is, a human being in the twenty-first century), you know that it's incredibly difficult to be fully present all the time. At any given moment there may be numerous thoughts, feelings, and sensations competing to distract us and draw our attention away from the moment—incidents from the past to ruminate upon, concerns about the future to worry about, an upcoming task to plan for, a grumble from your stomach that makes you think about what to have for lunch. Yet staying in the present moment, even when it's uncomfortable, is one of the best ways to gain a healthy mindset. Being able to tolerate discomfort is truly a superpower. And knowing that the discomfort is always temporary is the (not so) secret weapon of mindfulness.

This is one of the reasons that I have felt that my creativity could be such a powerful tool for my mental health. It was one of the first coping mechanisms I resorted to that felt healthy and made me feel deeply satisfied. I want to help you reach that same place by learning the art of imperfection and developing a mindful sketching practice. Moving into a creative place when you are feeling uncomfortable—instead of reacting in the moment, often in an unhealthy way—gives you the space you need to pass through the negativity and come out the other side. Let's dive into how we can integrate our creativity into mindfulness.

Mindfulness and Sketching

I'm so excited to take you through what I have found to be a rather profound adventure in discovery, which at first glance appears simply visual but runs so much deeper. It is powerful to create something and add your own unique spin on it through your style, selections, energy, or all the above.

I encourage you to make this experience your own. As you connect with your creative side, know that *you do not need to know how to draw*. Sketching your surroundings is even better when your efforts have an organic energy without perfect lines, proportions, or symmetry. Being free in this way will allow you to cultivate a deeper connection with all that surrounds you.

I first felt the impact of this style of sketching when I came across a piece by James Richards. I not only saw this artwork, but I *felt* it.

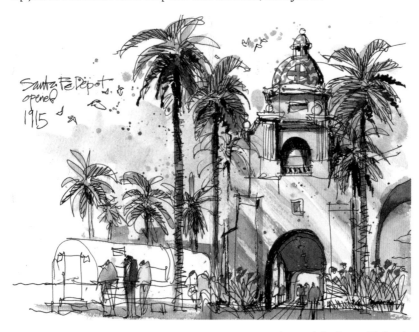

Artwork by James Richards

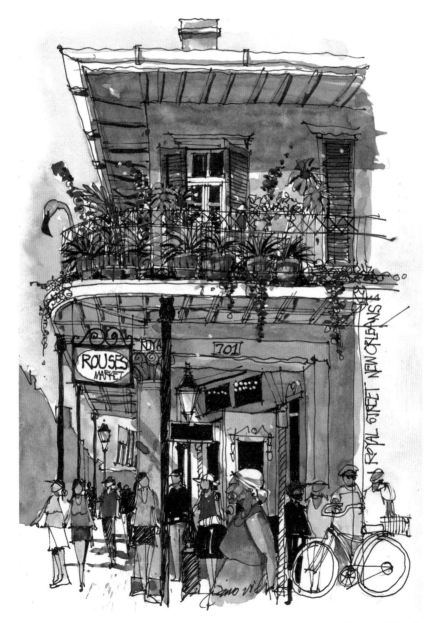

Artwork by James Richards

From the vibrancy of his color choices to his expressive lines to his intentional subject matter—a bustling crowd, greenery, and old architecture captured in a way only he can—I saw the unique beauty of it.

Each style you come across will have a different feel. A group of people can draw the same subject and each interpretation would be specific to the person who created it, whether on purpose or not. See, for example, the following artwork from three different sketchers. We can't hide from our own unique creative interpretations on paper: It's a beautiful thing.

Artwork by Felix Scheinberger

Artwork by Ohn Mar Win

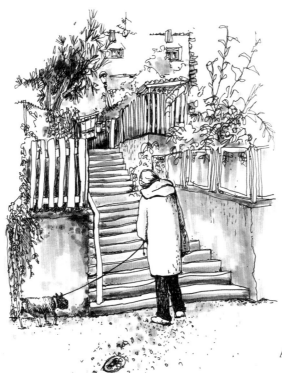

Artwork by Riona Kuthe

This is a small roundup of some of my favorite sketchers, all with vastly different styles, yet all of them draw us in so that we really feel what they are expressing.

Benefits of Developing a Sketching Practice

Have you ever noticed upon reflection that a cramped road trip, a long waiting period, or some other experience that might have been considered an inconvenience yielded a silver lining based on some minor or unexpected thing that occurred? Sometimes the memories we have highlight the best moments during those times rather than the final result or destination. I had a paradigm shift when I adopted this mindset after noticing my own thought reflections. Suddenly, what I used to consider moments of unimportant or even annoying "in-between times" became memorable and important.

It's about the journey. So do it for the process.

the end
result
is just
a bonus

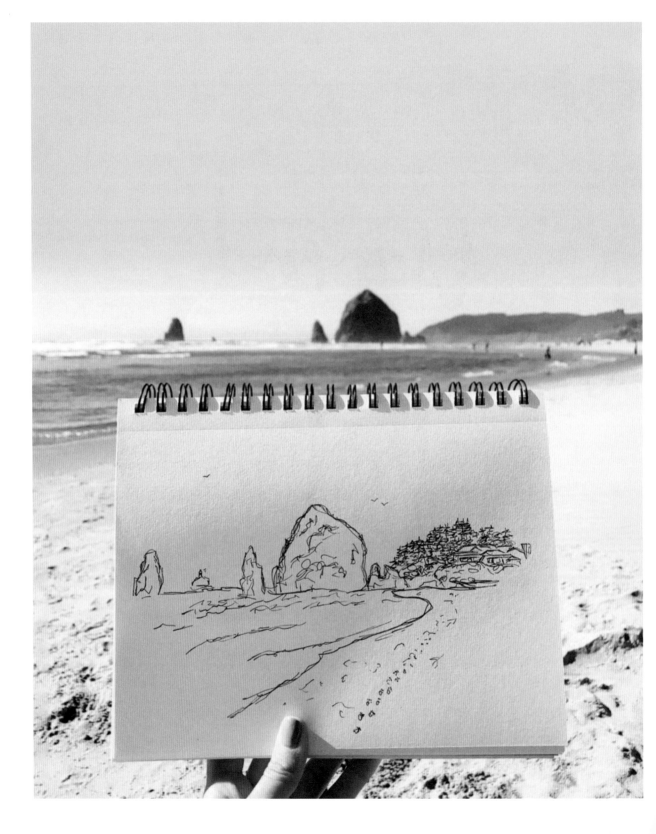

Materials

I never, ever, ever sketch with pencil first. Not everyone adopts this method but I've never started with pencil because I believe that it makes me second-guess where I create my lines and affects the natural energy of the way my hand wants to move as I create. I think there's something special about being free to make mistakes and allow them to exist without feeling uncomfortable.

I want to really emphasize that you can work with what you have. You don't need fancy art supplies or a designated creative space. Think of how many famous artists have sketched on café napkins with coffee ring stains. It's pretty much iconic. If you have a ballpoint pen, that's perfect. If you have a marker, that's also perfect. Lined paper? Check. Anything will do when you're on the go. Napkins? Even better.

In case you do want to grab a few supplies, however, allow me to introduce some of my personal favorites.

Archival Pens

Permanent ink is my go-to because oftentimes I end up adding water-color to my pieces after I draw them. If you use a pen that doesn't have archival ink, using water-based media over the ink can cause your ink to smear and ruin your sketch. No good! I recommend The Pigeon Letters Monoline Studio Archival Drawing Pens, which have a slightly rounded tip and are ideal for drawing.

Mixed-Media Paper

I'd also opt for mixed-media paper so you can add any sort of medium that you want. A lot of sketches are brought to life even more when accompanied with simple watercolor washes, and you want paper that can handle that. My favorite is a mixed-media sketchbook made by Strathmore. It has a soft, almost velvety cover that shows indents and marks, and by the time you've filled it with your sketches, the cover shows the journey it's been on with you.

Optional Additional Media

If you decide to add color later, I love using watercolors. Simple splashes of color can go a long way. I'm sure you've heard the phrase "less is more." Most of the time, I continue using what simply feels good to use. If you enjoy the process of creating, that's what counts the most.

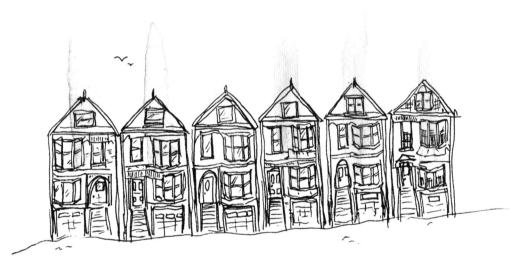

san francisco
painted ladies

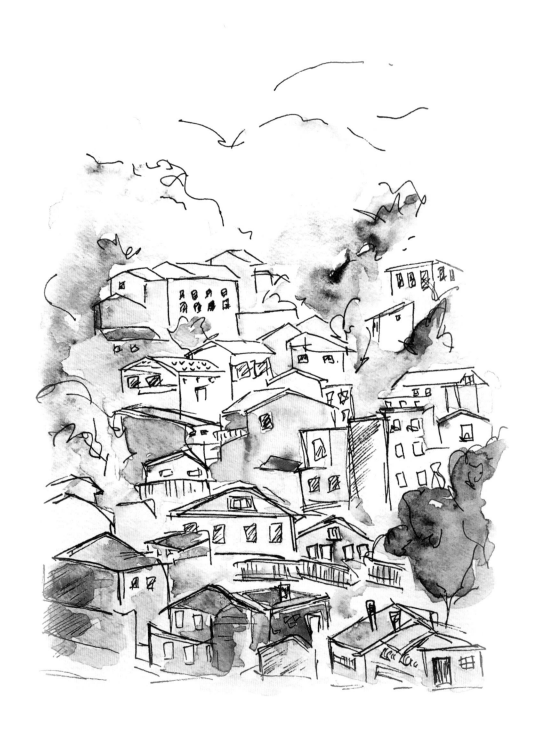

Sketching with the Goal of Imperfection

Sketching is not photography! When you draw without limits or guides, you can make the work your own. You can allow for wobbles and irregular shapes and wonky proportions—and some people's least favorite word: *mistakes*.

If you tried for perfection, your art would instead be technical, flat, and, some might even say, boring. Look at the differences in these house sketches, for example.

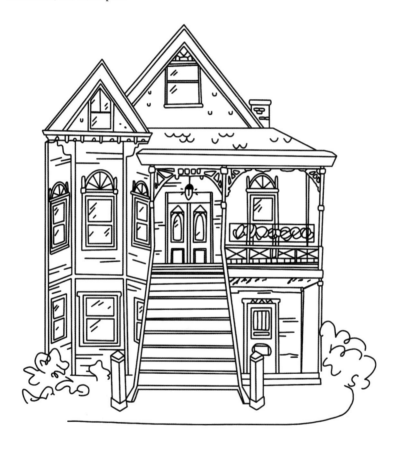

Which one draws your interest more? I'm willing to bet it's the imperfect version. The so-called imperfections add character and coziness. Again, sketching is not photography. We're not trying to win an award for most photographic freehand sketch. We're simply sitting down and enjoying our surroundings and taking a picture with pen and paper instead of a camera.

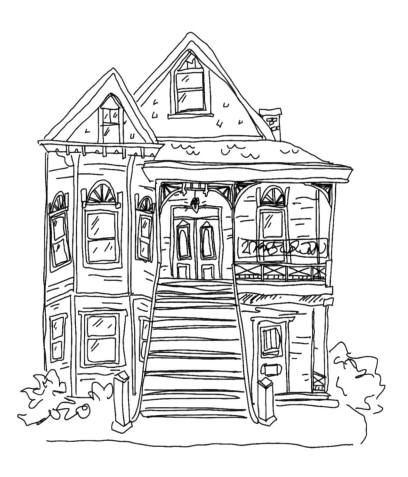

While I'll be introducing you to some basic sketching rules to help guide you, I want you to think of these as guidelines, not rules. Follow them loosely and allow yourself to feel free in your sketching practice. There's not a right or a wrong way for how you show up in your art. Please embrace imperfection as it arises and celebrate your "mistakes." (If I may say so, you'll find this works in all areas of life.)

I've noticed that jumping in with ink first creates opportunities for mindfulness and awareness. It forces me to feel the uncomfortable feelings that accompany "failure." It allows me to persevere and figure out how I can work in what I feel might be the mistake so it seems intentional. Let me tell you, nothing will help you learn faster than learning from your mistakes. It makes me a better sketcher because the next time I whip out my pen and paper, I've learned from previous sketches what I want to avoid or do differently moving forward. If I had used pencil from the get-go, it would have been a lot harder to learn those lessons because I'd constantly be erasing and making my sketches look how they're "supposed" to look. Remember: It's *your* sketch. It can look however you want it to. Give a box of crayons to a child and see how much they care about what things should or should not be. I dare you to go a week without using the word *should*.

When we take photographs, we record that exact moment. Let's say you see a beautiful building and you are taken with its incredible architecture, so you decide to take a picture. Later, when reviewing the photos you took, you might see some unsightly items that you didn't initially notice. Maybe a construction zone at the bottom with a dust cloud or a line of cars parked in front that take away from that initial majestic awe that you first felt and tried to capture. There can be a whole plethora of eyesores, such as street signs, garbage, traffic cones, and other things that detract from the beauty. When you sketch your surroundings on paper, however, you have the luxury of choosing which details you want to record and which ones you leave out. Everything you want to remember is your choice. That's pretty magical.

See with NEW EYES

What Energy Are You Attracted To?

One of the questions I hear most often is, "What should I sketch?" A blank page can definitely be intimidating. Some people are great at diving in, but many more tend to freeze up with decision paralysis. It can be a lot simpler if you don't get caught up in the stuff swirling around your head. It's all about diving in loosely. So let's get over that initial creative block by asking some discovery questions.

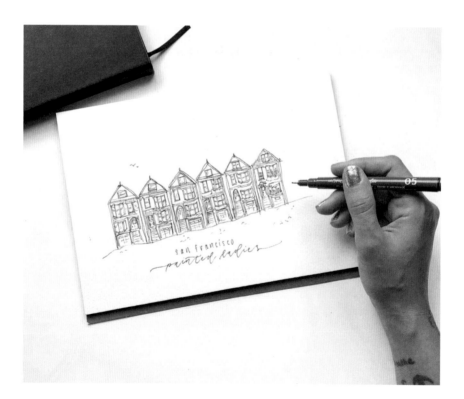

THINK ABOUT A PLACE YOU ENJOY

Whether you see it from the outside or from within, think about what draws you to a place.

WHAT DRAWS YOU IN?

This all comes down to the energy you feel around it. It might be a comforting smell from a corner bakery or an enticingly lively hot spot or a colorful amusement park ride.

WHAT IDENTIFYING CHARACTERISTICS DO YOU NOTICE?

- Objects within or surrounding a location

- Type of energy (bustling activity, calm and serene, etc.)

- Activities taking place

- Colors or smells

- Weather

- Character

- Architecture

- Shapes

- Texture

- Signage

As an example, I'll use the interior of a beautiful A-frame Airbnb I stayed in at my favorite spot on the coast of Oregon. Walking through my list of identifying characteristics, I'll choose to sketch the interior.

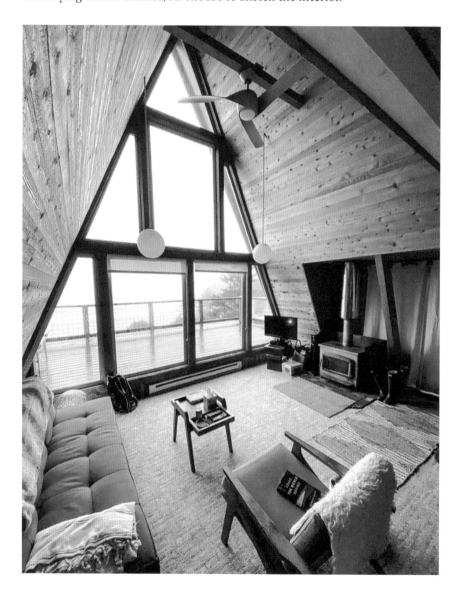

While I can note all the items I see, I actually only want to put down on paper those that bring me feelings of joy. I want to capture items that feed the same feelings I have when I'm inside that space.

- **Objects:** Fireplace (so cozy), couch, chair, table, rain boots (we love agate hunting on the coastline, so including those is a must!), hanging lights, books (a lot of cozy reading gets done here), rugs, and throw blankets. (Notice that I didn't mention the TV; that's because we didn't use it and it's not part of the warm feelings that this precious place brings me.)

- **Type of energy:** Calm and relaxing, a break away from it all

- **Activities:** Reading, watching the ocean, lounging and conversation

- **Colors or smells:** Natural earth tones

- **Weather:** Usually overcast and rainy, perfect for a blanket and a book

- **Character:** Rustic

- **Architecture:** Gotta love that A-frame

- **Texture:** That wood . . . 😊

Thinking about these defining characteristics really helps me connect to the space around me and brings me closer to my experience. Once you develop your own sketching practice, these elements will present themselves automatically as you sketch. The process becomes quite intuitive as you dive in.

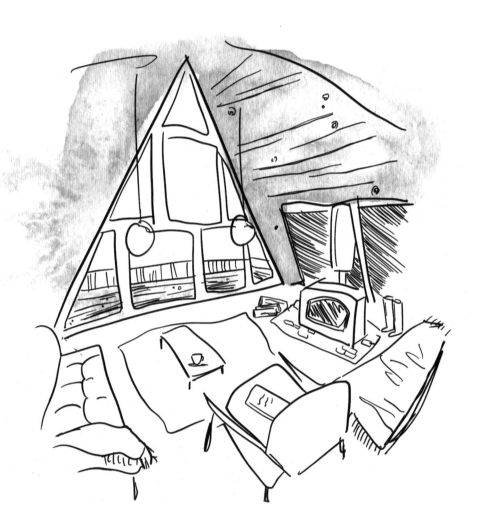

CHOOSING A SAFE LOCATION

As we get excited to sketch unique places, it's important to always be safe. You might know of an awesome alleyway with cool architecture but miss that it's a dangerous spot where you might not be safe. You don't want to get yourself into any bad situations, so err on the side of caution when you sketch on location, and always let someone know where you are.

TAKE ADVANTAGE OF WAITING

I have mentioned using the in-between moments in life as opportunities, but I want to tap into this more. A great example that I can think of that you've probably seen at some point is the sketches of a jury made during a trial in a courtroom. If you've ever had to sit in court, you know it can be the longest process. So why not use that time to open your sketchbook? I'm a very impatient person, so if I can suddenly shift my paradigm and enjoy waiting because it means I get to sketch, you can too. And I want that for you.

Here is a list of some places to sketch while waiting:

- DMV driver's license renewal or other government office

- Medical or dental office

- Amusement park

- Airport

- Public transportation (bus, train, ferry, plane, taxi)

- Restaurant

- Salon

- In line for a movie, concert, or other event

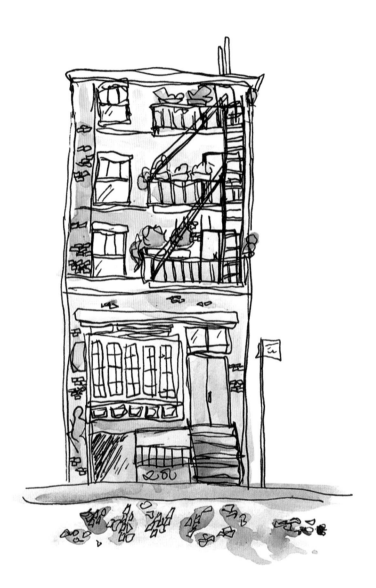

How many more can you think of that apply to what you do
in your day-to-day life?

LESS IS MORE

While you want to pay attention to the objects in a scene, try to avoid the feeling that you need to include all the details. You will find that less is more in many circumstances. Many places you want to sketch will be quite layered and complex IRL, but you don't need to capture every single element. For example, if you are drawing a particular building, you don't need to include the neighboring buildings, even if they do attach. This also applies to other details you see. You don't need to re-create a million bricks on a wall just because it's a brick building. (More on this as we dive into sketching together.)

Remember, this is your sketch, and you are always free to alter a scene. During one of my outdoor urban sketching workshops, many people chose a scene to sketch that happened to have a giant obstructive flagpole jutting up in the middle of it—and they felt relieved knowing that they didn't have to include that in their sketch. Some decided to keep it. It's your interpretation of what you see, so you truly have the freedom to make these decisions according to your own unique creative inclinations.

SUBMERGE YOURSELF IN YOUR SURROUNDINGS

Just because you might be looking at a big, beautiful work of architecture doesn't mean you need to take on the whole thing. Look deeper, get closer. Maybe there's a cute café with a quirky vibe on the bottom side of the building, and that's what you decide to sketch. Go in even closer, and you might find that you love the barista's bar area and the way the steam rises from the espresso machine accompanied by the shape of the mugs. See how you can take an overwhelming scene and channel it into a feeling simply by immersing yourself in it via your senses: watching the steam, smelling the fresh espresso, tasting the coffee . . . There's more to sketching than at-a-glance viewing (looking at you, delicious bowl of citrus fruits).

TYPES OF SCENES

While the scenes you can sketch are truly limitless—literally, you can sketch anything you please, anytime, anywhere—I find the most joy in sketching industrial and downtown spaces. There are also plenty of sketchers who prefer to focus on objects; their sketchbooks are a record of the details of their days, such as what they had for breakfast, a book they're currently reading, their afternoon bike ride, or a berry-picking excursion. You can sketch what makes you happy. Never feel restricted to depicting just one type of scene.

I want to encourage you to connect to the familiar. The boring day-to-day route you walk to work or school, or wherever you go can come to life if you look at it differently. Seen with a sketcher's eye, your everyday routines may reveal a new treasure. Maybe it's the heavy ivy growing along the side of a city bridge. Maybe your office has a conference room with a view of the entire city, providing the opportunity to record a full cityscape. Maybe your favorite spot in your house is a little reading nook, and you start noticing little details like the fabric of your chair, the patterns on your curtains, or the candle you always have burning. All of these moments are yours to discover and then document with your interpretation as you take a picture with your pen and paper.

That said, it's also wonderful to get excited about grand, eye-catching places.

Disneyland, anyone?

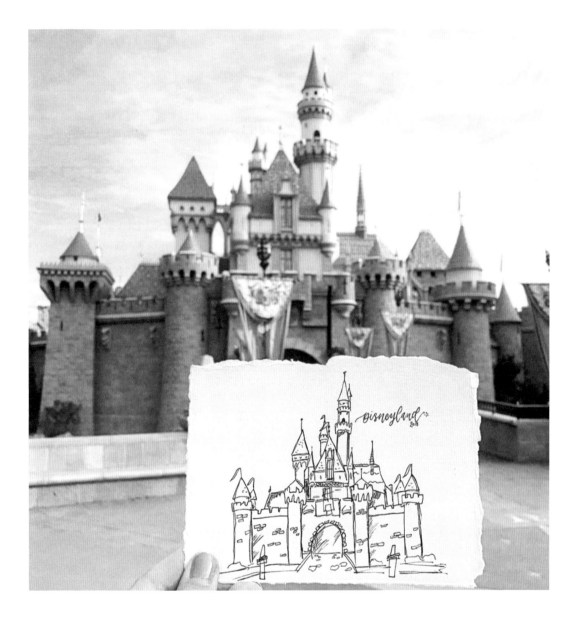

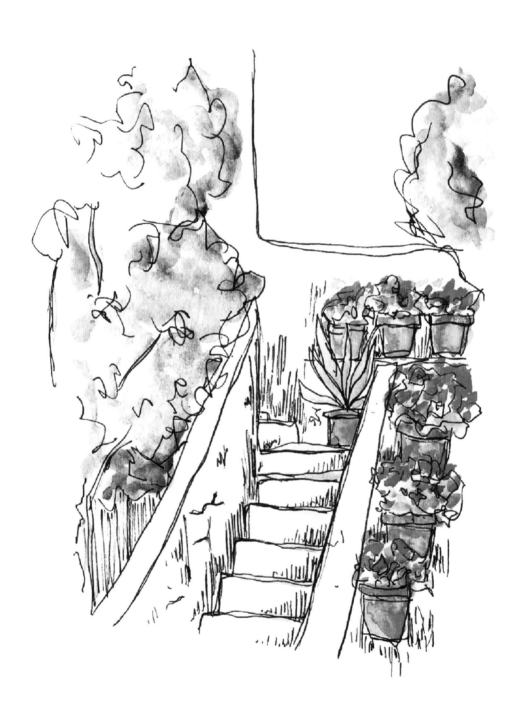

Techniques

Let's break down some of this stuff. It's easy to look at something that you would love to draw and then find yourself feeling overwhelmed. You may start thinking, *How can I possibly draw it?* I fully understand that. I'm an artist, and every time I sit down to draw, I genuinely feel like I don't know how to draw.

It is true that some people are born with a natural ability to draw, while others are not—instead they learn skills that they put to use every time they begin drawing. Neither of those conditions means that someone is or isn't innately creative. Being a person who learns how to draw does not mean that you are not "an artist." You are! It's just about approaching things differently.

In these pages, I'm going to help you learn and practice some techniques that will bridge the gap between what you want to do and what you can do. And those techniques will also help keep you focused in the moment when you are teetering on the edge of a negative reaction like *I can't do this*. You can!

Here is a great way to start: Instead of viewing what you know to be a 3D object in its full dimensions, flatten it in your mind. I'll show you what I mean using a simple still life example.

For this exercise I'm using a jar of paintbrushes and a special notebook that I use to record colors of earth pigments that I find during nature walks. And why am I telling you this? Because this is a part of choosing your subject matter with thought and care. I wanted to use an example that meant something to me so I felt more connected to the process as I sketch. After I walk you through identifying these shapes, I encourage you to find a scene in your own space where you can do the same.

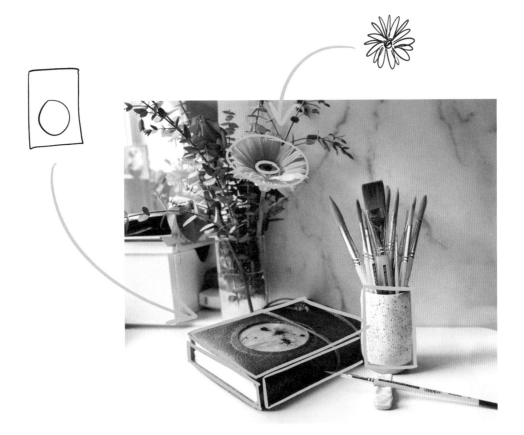

Our brains are familiar with the world around us, meaning that even when we view these objects from one side, we know that they extend beyond our sightline. We know that the paintbrush holder is cylindrical and that the notebook is rectangular. We know that the detail on the notebook is circular. We know that the face of a gerbera daisy is round.

In order to draw them, however, we need to "unknow" these things.

It would be easy to draw them as we know them to be, but instead, we need to identify their shapes from our viewing position. This is how we can break down the shapes in a way that allows us to translate what we see to paper. As you can see, I've broken down the main shapes in this scene. When you look at the breakdown, instead of the flower being round, it's actually oblong. The notebook is at an angle, with the top and bottom points closer together than the points on each side. This is a simple breakdown, an introduction to training your eyes to flatten and measure.

EXERCISE

Find something in your current space that you might like to sketch. It might be still life, such as a vase of flowers, or an architectural vista like a city view outside your window. Rather than trying to re-create it as is, instead draw the shapes and main lines that stand out to you. Don't worry about getting the details right or about making the objects look like what they are. Simply focus on drawing the shapes and lines you see. If that means drawing a bunch of rectangles, do that. Getting into the habit of drawing expressive lines helps you embrace the imperfection that will eventually be a natural part of your sketching practice.

Mindfulness is
a way of
befriending ourselves
and our
experience.

—Jon Kabat-Zinn

Perspective

Now that you understand this easy method for breaking down a scene to make it sketchable, we can talk about some of the trickier stuff, such as perspective. It can freak people out because the concept seems difficult, but perspective in its simplest definition is just a way to capture that 3D element on a 2D surface. The world is 3-dimensional but your paper is 2-dimensional, so you have to translate that 3D to 2D.

A really easy example of how perspective works is often explained by visualizing railroad tracks. If you look at the two parallel lines of the tracks extending into the distance, it looks like they meet when they reach the horizon—you know they don't, but the illusion that they do gives you the impression of distance.

Incorporating perspective into your work is what makes your sketches seem realistic and in proportion. It may appear complicated, but it's really not—and I'm going to walk you through it.

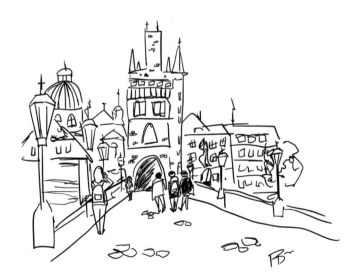

ONE-POINT PERSPECTIVE

One-point perspectives are the easiest to draw when you break out of what I'll call "doodle mode" (which there's absolutely nothing wrong with, by the way). You begin to show a bit of depth to your sketch by incorporating a vanishing point within the sketch. A vanishing point is the place in your sketch where your lines appear to either converge or disappear. It's where objects eventually disappear after getting smaller and smaller. It's setting up your perspective, which is the key element that the rest of the drawing will be determined by.

PRINCIPLES OF ONE-POINT PERSPECTIVES:

- The lines in the sketch are vertical, horizontal, or recede to the vanishing point.

- Vertical lines are parallel to each other, and horizontal lines are parallel to each other.

- Any diagonal lines are directed to the vanishing point.

- All objects become smaller and their lines become shorter as they reach the vanishing point. The closer objects are to us, the more details we include.

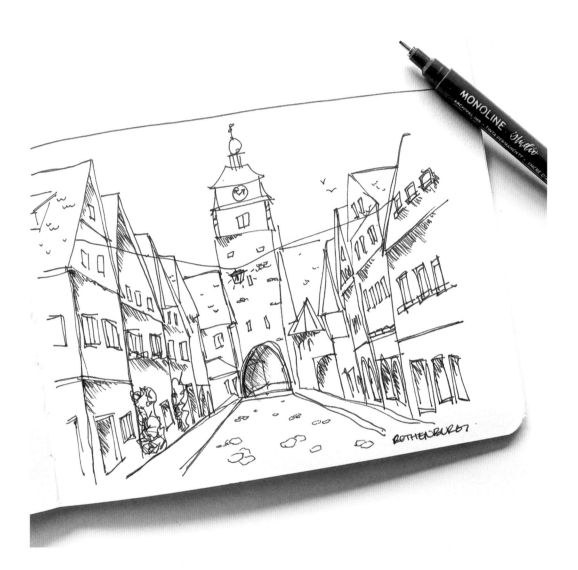

I want to walk through a full scene with you so you can see exactly what goes through my mind as I start a sketch, build it out, and then go back in to add detail. I encourage you to grab a spare piece of paper and draw along with me as we go through the breakdown of this scene.

Step 1: The first callout is always the horizon line. The horizon line is where the land meets the sky. It's always at your eye level. This term is generally used if you're outdoors, because if you're indoors, the horizon line may be interrupted by a wall. If it's a large space, you'll notice that the wall meets the floor at eye level. I can draw this line out on my page or I can choose to make a single small mark to use as a guide. I know a lot of sketchers who like their sketches to show this initial line because it adds that extra personal touch of being hand drawn in a moment of expression.

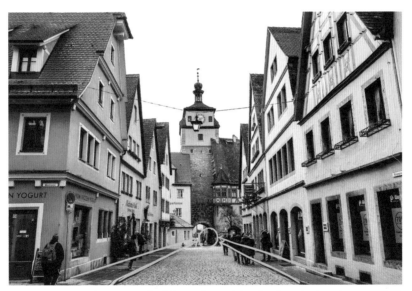

Image is from a wonderful trip through Rothenburg in the winter of 2017.

In this case the horizon line would be behind the building in front of us. You can figure that out by looking at the road and following the lines— you can see that you'd reach the vanishing point just beyond the tunnel. The vanishing point will sit along the horizon line. You'll also notice that it would place the horizon line at about one-fifth up the page.

Step 2: Identify the vanishing point. The vanishing point is where all the objects in your scene lead, along the horizon line. In this case we've already found it. You'd approach this step the same way though, depending on your view. I tend to either draw the horizon line or simply draw a dot at the vanishing point so I have a point of reference as I continue on.

Looking at the overall scene, you'll see objects getting farther away, whether they be buildings, trees, or people, and when they're lined up within the image, they all meet in the same spot—at the vanishing point. In this example, look at the rooftops along with the road.

Once you have identified the vanishing point, you can use the rest of the sketch as a guide. Allow me to break it down further.

Step 3: Identify the largest, main shapes of the scene. Most of the time when you're sketching, you don't have a photograph to work from, which means you won't be able to take a marker and draw shapes around the objects as I've done here. That's okay. You can do this in your mind.

After determining the location of the horizon line and vanishing point, you can choose where to continue. I always find this the easiest way to build up my scenes. For this scene I'll use the sidewalk and determine its approximate width, which takes up just over a third of the scene horizontally. Another thing to note is that as the road and sidewalks head toward the vanishing point, their lines do not meet up at a point. This is because we see the edge of the road instead. So we'll take the length of the end of the road, sketch it in, and have our sidewalks meet at the end of the road in our sight.

Step 4: Begin adding the smaller shapes within and around those shapes. Once the main shapes have been sketched out, you'll start working on building more detail.

Note: This is the really fun part where you begin to bring in the items that stand out to you. This is your moment! If you were at this place in person and you saw a darling little chestnut-brown dog being walked along the sidewalk and it filled you with joy, you'd sketch that little guy in. If you were at this place in person and it was raining and you saw umbrellas pop up all around you and it made you feel a sense of calm and refreshment, you'd include those umbrellas and add some marks to resemble the rain. Maybe draw some puddles in the street and a stream of water pouring from a gutter. These details can be minimal but, the ones you choose to include can create an entirely different vibe.

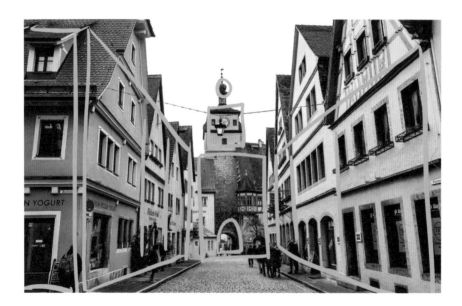

Remember, as you do this step, you don't want to add too much information near your vanishing point. Instead, concentrate your details farther away from it. This creates an illusion on paper that the items in the foreground (closest to us) are the items we see the most of, which is how we see things in real life. This is an easy rule to remember and ensures that the objects closest to us appear more prominent.

As you begin building the scene, look at the larger shapes. I like to identify what I can use as a guide to outline the main scene before I worry about the details too much. If you study a scene and flatten it in your mind, you'll start to discover these shapes and lines with ease.

Note: When you view buildings along a vanishing point, your eyes can deceive you about the sizes of things. Knowing this, avoid sketching your first shape too wide, which will leave little to no space for adding neighboring buildings. It's easy to mistake a "flattened" building as wider than it is; when you are just looking, you can determine the size of the building by examining it from other angles. But when it's flattened into shapes and lines on paper, it's harder to determine the space it takes up. A quick measuring trick will make all the difference.

Since I've already drawn my sidewalk, I can use the bottom width of it to measure against the tip of my pen. Then I can hold my thumb in place to measure the building's width, noting how many sidewalk widths it takes to create the width of the building. You can use this same technique when you're outside in front of a scene by extending your arm all the way out in front of you, closing one eye, and measuring with the tip of your pen. Important: The length that you measure on the tip of your pen this way is not usually the same as when you do it on paper. This means that once I discover that the width of my building is about one and a third of the width of my sidewalk, I'd measure my sidewalk in my sketch with my pen tip, doing the same process for accuracy. I'd take that length and use the same measurement to draw my line. Make sense? (Cute reminder: Don't overthink it. These instructions come to you with grace and forgiveness, ha ha!)

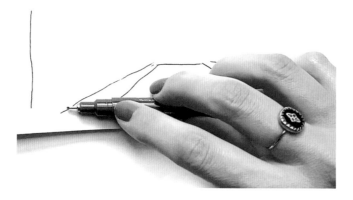

As you draw the vertical lines of the buildings, make sure that you don't extend the lines past the invisible line connecting the tops of the buildings to the vanishing point.

Now, I'll be honest. I don't spend a lot of time measuring anything after my initial guide is laid out on paper. I can even get a bit sloppy after that, but to me it adds character—and I live for those wobbly, imperfect lines. What are we embracing here? This is when you get all excited and jump out of your chair and fist pump the air and scream, "Imperfection is fun!"

Now we are going to break the rules a little as far as all diagonal lines going toward the vanishing point: roofs. It's not hard, so don't worry. Just line up your pen vertically and note the approximate angle and draw the line in. And hey, if it looks a bit off, oh well! Just push on—you'll be pleasantly surprised with the outcome, I promise.

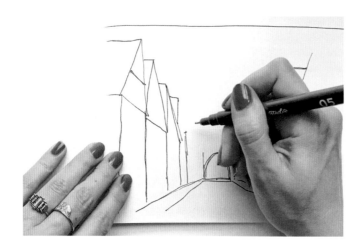

Step 5: Repeat step 4, but this time with more focus on even smaller elements. Repeat this until you're happy with the items you've included.

At this point you'll simply want to remember the vanishing point and keep windows and other objects along the same plane. I sketch in these objects and features very loosely. I don't worry about drawing the precise number of windows. I don't worry about including every object in the scene. I don't worry about ornate details, unless those are something I want to feature.

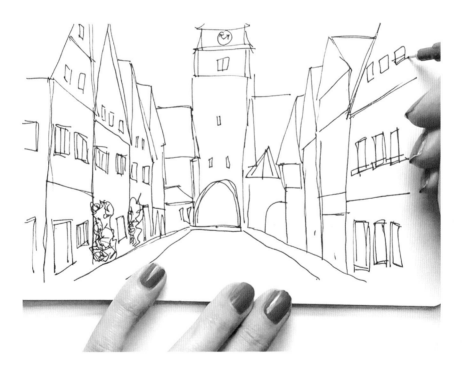

A lot of the detail I leave out is usually because it would detract from the overall scene and highlight a particular area, ruining the flow of the sketch. For that reason, I leave all of those kinds of details until the very end.

Step 6. Less is more when it comes to details. I like to add a few marks in rather than the entire bulk of roofing, siding, patterns, etc. Notice that I've added simple W-marks for the roof tiles, stacked rectangles for the brick wall of the tower, and groupings of imperfect ovals for the cobblestone streets. I find that including less allows the imagination to fill in the rest instead of having it drawn in.

Step 7. Start to bring in contrast by adding mark-making techniques to create depth and shadows. Now that you've finished sketching your scene, it is time to add contrast, which helps give the scene more dimension. I create shadows with parallel lines called hatching (more on this later).

And just like that, this scene is complete. Are there technical issues with my sketch? Absolutely. But is it imperfectly perfect? You know it!

It's as simple as that. You can always add a fun pop of color to breathe more life into your sketch as well. Look at the difference between the photograph of the sketch and your sketch. It is totally transformed when we re-create it with ink on paper. And don't worry if yours doesn't look like mine. It's not supposed to!

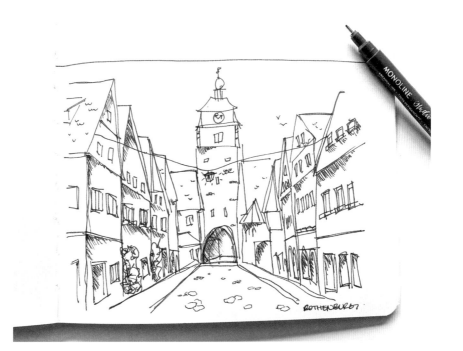

EXERCISE

Here's your chance to practice what you've learned about perspective. It's time to break down a scene on your own! Look at the image on the facing page, and identify the horizon line and vanishing point. First locate the horizon line, then pick out the vanishing point. Bonus points if you also mentally outline the shapes that you see in the scene. Don't worry about completing the sketch. We still have a lot to cover. (But if you want to have a go at it, I get it. Jump in! It's never too early.)

When you have a good understanding of how to identify vanishing points, you'll feel a lot freer to play with the other elements in your sketches. It's a "learn the rules to break the rules" kind of thing.

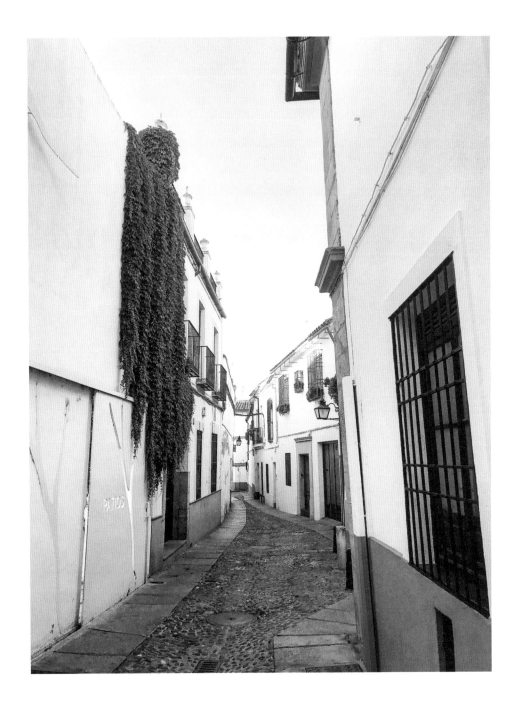

Image is from a magical road trip through Spain in 2018.

TWO-POINT PERSPECTIVE

Now let's break down a scene that shows a two-point perspective. This comes in handy if you're standing on a corner and see two vanishing points, which is to say you see two sets of parallel lines moving away from you. The same principles as for one-point perspective apply here, you just have to double them. Not too hard when you know the fundamentals of perspective, right?

If you've isolated a space when you're out in the city or nature and you see a two-point perspective, think of each vanishing point as two sketches in one. Treat each as its own—because that's exactly what they are. Sometimes the vanishing points won't be along the same horizon line—for example, if there is one road traveling upward on a hill and another much lower that is going downhill. When you treat them as the subjects of separate sketches on the same page, it's easier to break them down and capture them without feeling overwhelmed.

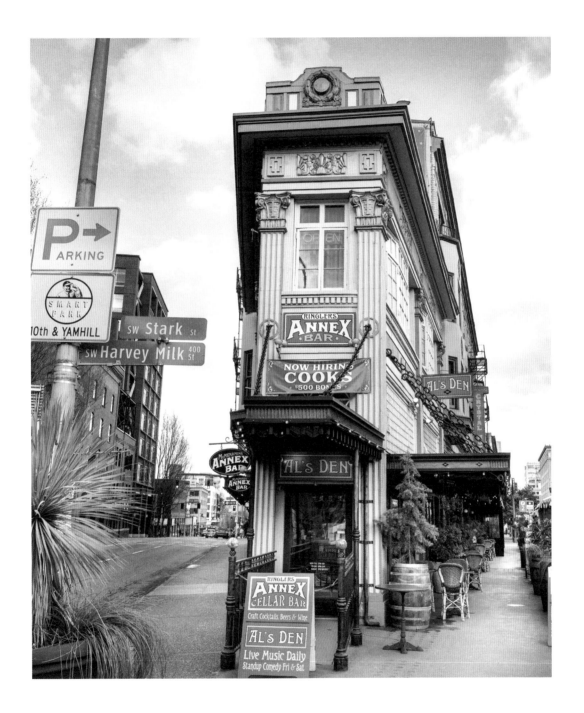

Here's a photo I took of the Ringlers Annex building, which was built in 1917 and is located in my city of Portland, Oregon. This image is a great example of two-point perspective. It features what I find to be a darling, skinny little building that expands on an angle of two streets that break into a Y-shape. On one side of the street, you can see the main road. On the other side, the street has been closed to allow for outdoor dining. I chose this location because of its unique Romanesque Revival-style architecture, which is so much fun to sketch, and also because I find its situation on the triangular lot just extremely appealing. It's a historic landmark that always makes me feel good when I see it. And that makes it a perfect choice for a sketch.

For some two-point perspective scenes, if there is something obvious such as a building in the center of the scene, you could start there. Alternatively, you could choose to start with trees or other elements. You might choose to map out the vanishing point lines by drawing whatever is along those lines. There are technical rules, of course (which you should research if you like to follow rules!), but for this particular scene, I'll perspective-walk you through exactly how I'd approach it in my sketch.

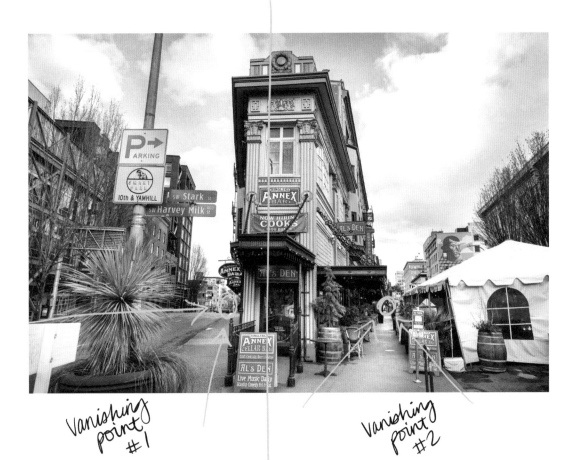

Vanishing point #1

Vanishing point #2

Note: It was only by chance that I managed to capture this photo without traffic. You don't need a scene to be free of the regular parts of life—it's fun to include cars and people in your sketches, so don't think you have to leave out all of those things that make up the bustling energy in a place.

This time I'm going to draw my horizon line all the way along the page because I think it'll be a fun representation of my sketching experience. Remember that the creative process is intuitive, and you should do what feels good to you in that moment. From there I'll place the first eye-catching shape that I see, which is the long rectangle that makes up the front of the building.

The horizon line is about a quarter of the way up horizontally, and the building is skinny and reaches to the top of my chosen scene. My horizon line is a bit wobbly this time—this is intentional. If you want a straighter line, simply use more of a sweeping motion using your wrist or your elbow rather than a shallow grip with just your fingers.

Remember that mapping out the larger, main shapes first is best so you can determine what details you want to include and which ones to leave out once you see the scene as a whole. You don't want to detract from the key points in your scene by adding detail somewhere now and then realize later that you wish it didn't have such a strong focus.

Now I'll work on the right side and treat that vanishing point as its own sketch. Because I know that the roof leads toward the vanishing point, I've drawn that at a downward angle. Before I draw the edge of the building, I see that there's a prominent awning on the side of the building that I want to include, so I've drawn that part in first and then drawn the side of the building vertically toward the ground.

Okay, let's be real for a moment. This looks kinda rough, right? It's good to know that in the beginning stages of a sketch, things are going to look unfinished. That's totally to be expected. Don't be discouraged by seeing your work in progress, and definitely do not let that feeling of worry that it's not looking "right" deter you from continuing. This is all a part of the process. Stick with it and as you keep working, you'll watch your sketch build upon itself and develop into something you will love, all according to your own special creativity.

Notice how I haven't exactly sketched in the ideal seating situation? Instead we've got some C-curve blobs. Totally acceptable! You'll also notice that I'm headed toward the right side's vanishing point more.

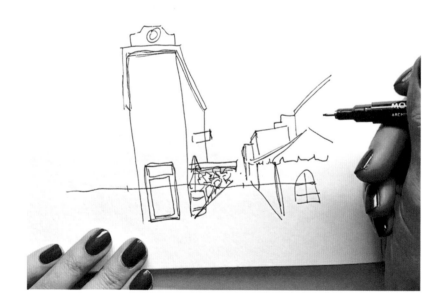

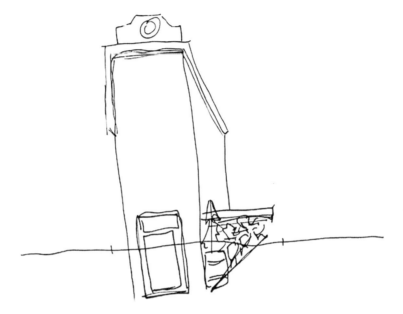

You'll also see how this side of the scene is turning into its own mini-scene as we focus on its vanishing point. See how easy it is to turn a two-point perspective into a manageable viewpoint?

After building up the right-side vanishing point, I'll move over to the left side of the drawing. Now let's talk about what's in the foreground. Before, we could easily determine what was directly in front of the eye

and start from there. This time, since I love this plant and also the street signs, I need to draw them even closer to me, and I need to do it in a way that they won't look like it's out of place. To accomplish this I'm simply drawing what I see. When you sketch on location, you will find that using your viewfinder will be such a big help in knowing how the frame sets up what's in your immediate foreground (that is, what may be falling off the page). Remember what you learned about measuring according to the scene horizontally and vertically, along with measuring against other objects that already exist in the scene.

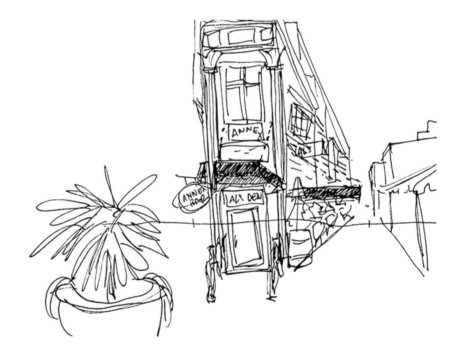

After sketching the street signs, begin to incorporate the buildings in the background using the same principles and following the left side's vanishing point. After adding all the detail you want and any shading you decide to complete it with, you're done!

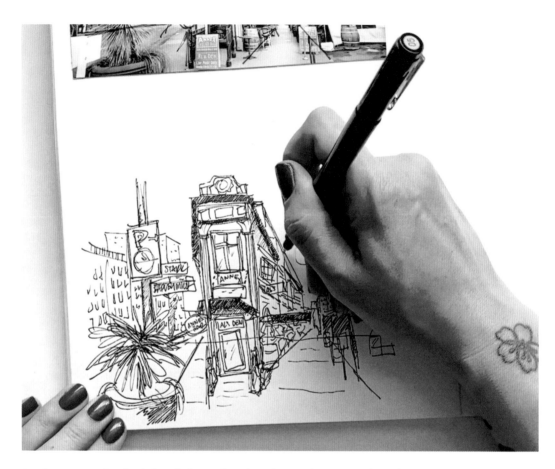

See how in my finished sketch I've isolated each vanishing point but it's combined in one sketch? *Easy-peasy!*

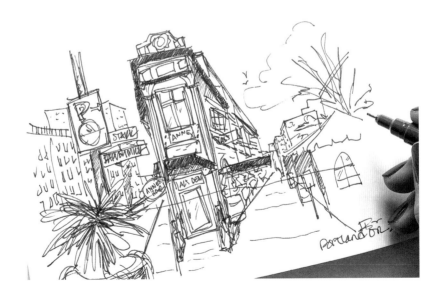

SCALE

In breaking down perspective in simple terms, I mentioned that objects get smaller and smaller as they recede toward the vanishing point. When items are clearly along a vanishing point line, it's easy to see how much of a frame they make up. So what if you're sketching a scene that's flat? How small or large should items throughout the sketch be?

As a reminder, don't strive for perfection here. If objects are perfect in proportion and scale, you end up losing the organic and quirky element of your sketch that is begging to come out and play.

That said, as a rule of thumb (literally), I tend to take my pen and hold my arm all the way out. Then I close one eye and adjust my thumb so that the distance between my thumb and the end of my pen measures exactly how long something is. This does nothing for my initial object, but it assists me in the objects that follow. So the object you choose to measure should be an easy shape to then measure against everything else. For example, a window might take up half of your pen cap. Knowing that, see how many times the height of that window takes up vertically on a door. It might be two times. That would show you that the door will be twice the height of the window. It's a simple trick that might help if you're feeling stuck.

Pro Tip: Always hold your arm all the way out when you're measuring.

There's no way to gauge the distance if your arm is constantly at different lengths.

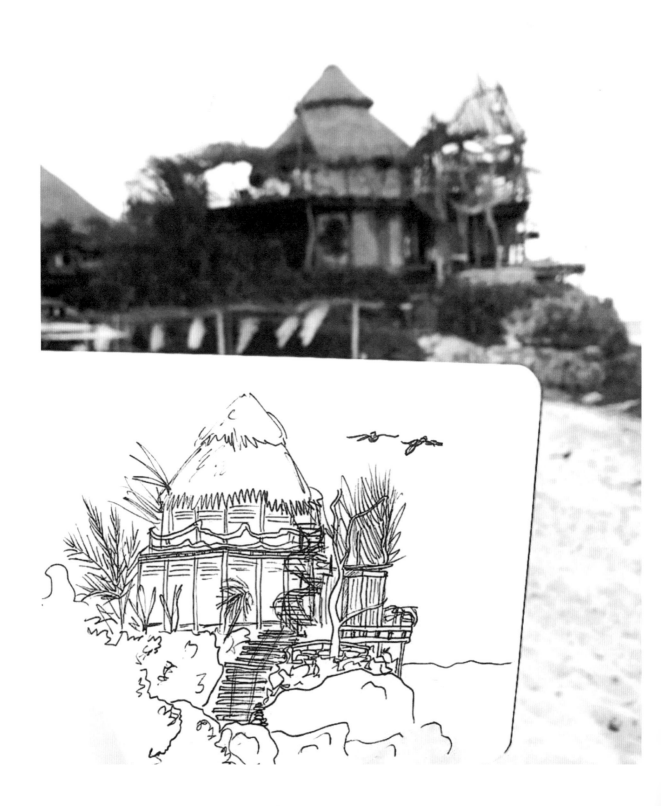

Framing a Scene

This part is easily one of my favorites and here's the reason why. As mentioned earlier, I always surprise myself when I isolate a scene a little more than I originally intended. I notice little nooks and crannies or opportunities for reframing that can add so much more interest to a scene when I try this.

I find that it's much more difficult to see those special details without being intentional. By isolating certain areas, our eyes are drawn to completely new aspects of what we're looking at. Maybe a tree that blended in before suddenly becomes front and center and demands to be captured in a sketch. Maybe a floral stand becomes an isolated scene of the workstation, complete with shears, twine, and cut stems. A street scene downtown could be isolated to simple door frames that showcase an old street's architecture.

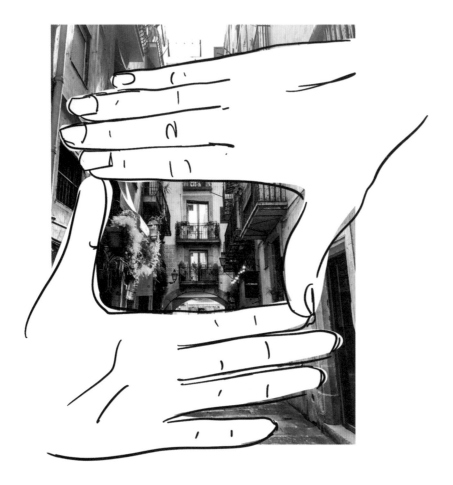

The easiest way to view a scene in multiple ways is by using a view-finder. You can create one out of cardstock by cutting a rectangle out of a small piece of paper. Or create one by simply using your hands: Hold your hands in front of you with the tips of your fingers and thumbs touching to create a rectangle. This creates a space framed with your hands that you can move around to look through. Try rotating between a horizontal and portrait orientation too!

This scene is beautiful as it is and while I could sketch the whole thing, let's look at some different compositions that I could pull from it . . .

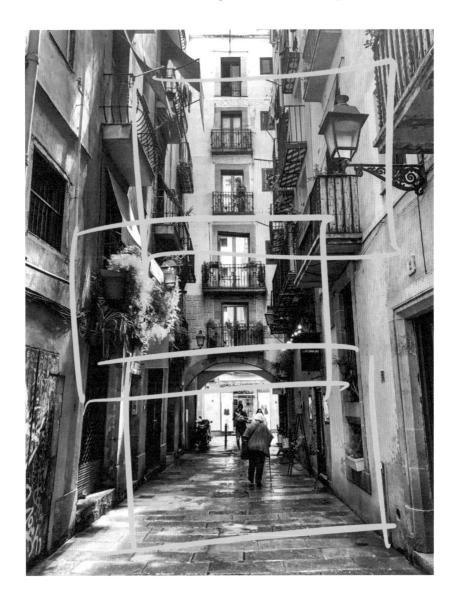

1. **People**

A sketch that focuses on the people in the alley tells more of a story. One of the things I like most about this particular scene is that all at once, it cycles through different life stages. We've got an elderly person walking with a cane, plus two parents, one of them holding a toddler. There's a lot to be translated onto paper as we honor these people's stories by sketching them.

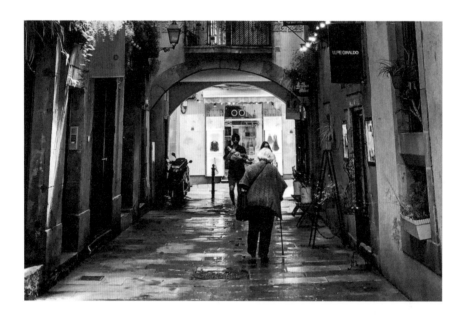

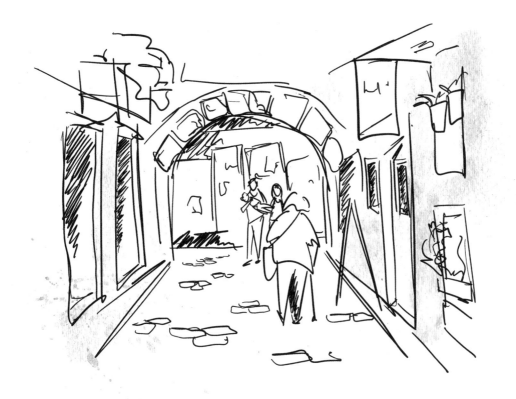

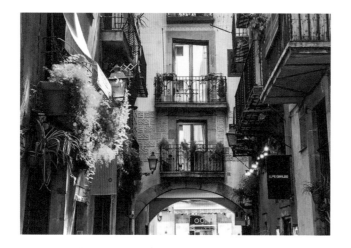

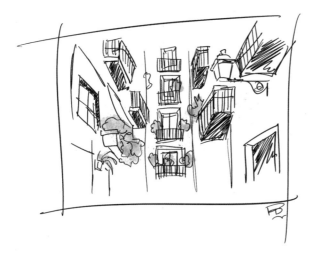

2. **Balcony plants**

Move up the scene and you can isolate some beautiful balcony plants. Just this simple reframing offers the chance to tell an entirely new story. This view shows spaces that are actively tended but without people included, which calls upon viewers to use their imagination to interpret the lives lived here. Additionally, because it focuses on the buildings, it shows off the architectural details, essentially bringing in another work of art.

EXERCISE

Going back to the image from the two-point perspective example, identify a scene within that space that could make a great focus for a sketch.

The chance to revisit and re-experience our feelings about a particular space makes this aspect of sketching even more memorable. You already know why I chose this scene (cute reminder: the historic landmark that is the triangular Ringlers Annex building in Portland that makes me feel oh, so good). I challenge you to do this within your own town or city. Find some spaces that give you good feelings and decide on a plan to sketch them.

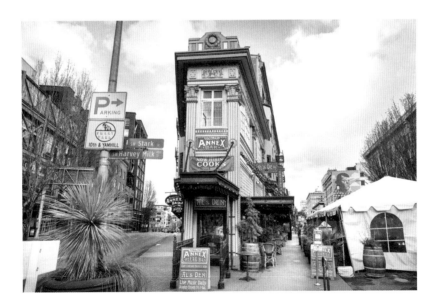

The Power of Expressive Lines

I said it before and I'm saying it again: Sketching is an art form in itself. It's the most energy I've ever felt from a piece of paper. Have you felt it yet? The more you make sketching in a practice in your life, the more you will be able to feel and harness that amazing energy.

Whether you've never drawn a single line in your life or you've been drawing since you were five years old, you've got your own special energy inside of you that will come out in your sketches.

If you are feeling inhibited and nervous, that is going to make it a little more challenging to explore your creative energy. As you grow more comfortable with your sketching practice and with your skills, however, you'll find that energy rising up whenever you see something you want to sketch.

One of the ways you can express your creativity is through your line work. I'm going to walk you through the basics of lines next.

embrace
imperfection

When we write, our fingers are typically pretty close to the tip of the pen. We do this to have better control. The child in each of us who learned penmanship and had to circle the best As, Bs, and Cs maybe lost the innate childhood ability to embrace imperfection—but let's break out of that mindset for the purpose of re-embracing our creative natures. Loosen up your grip and pull your fingers away from the tip of your pen. Allow your ink strokes to flow in whichever way you want your hand to move.

When we write and draw, the way we move our hands and arms can result in vastly different outcomes.

A looser grip that is guided by the elbow will result in a smoother, longer line. Holding your pen with your fingers farther away from the tip will allow you to move a little more freely with your strokes and focus more on an overall outcome rather than details.

A tight grip with guidance from the wrist will result in a darker, wobblier line.

Play with these grips to your advantage to discover what feels right for you. I won't tell you that there's a right way because I don't believe there is. I will even go as far as to intentionally make my lines wobble and overlap because I love the look of it in my work.

Multiple passes through a line came up for me when I thought I messed up. Rather than tossing it and starting over again, I redrew the line and then added some additional second passes through other lines in my sketch so it would look like it was on purpose. From then on, I've kept this style in my sketches because it felt right. There is rarely a mistake in your line work. There is only showing up and making it yours. *Own it and embrace it.*

EXERCISE

Practice gripping your pen in different ways. Allow your hand, wrist, and arm to take turns guiding simple lines. Take note of the ways your strokes show up on paper. Are they smooth? Messy? Jagged? Does the ink skip? Does the ink stroke fade (fast strokes cause this)? Are they light or dark? Are they bold or thin (determined by your pressure)?

wherever
you are,
be all
there.

-Jim Elliot

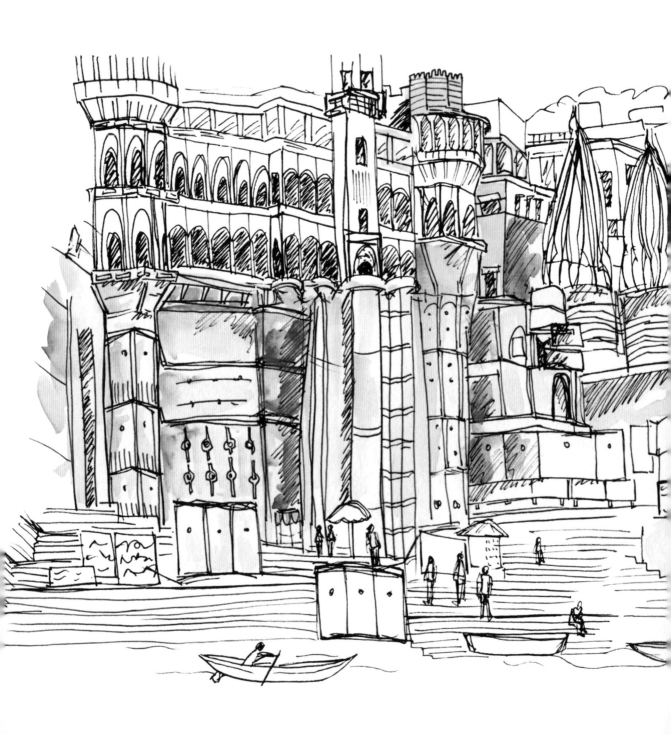

Capturing Moods in Sketches

All right, so now you've listened to me blab on about expressive lines and the energy in sketches. Let's dig even deeper!

There are so many types of energy in this beautiful world, and you have the opportunity to tap into that energy and translate it into something visual and lasting through your sketches. You can change the feeling of the energy you capture and even the meaning of what you sketch by choosing to make simple additions to your scenes—or by deciding not to. Choosing not to include certain additional elements can also create a specific kind of energy.

Next I'm going to go over some techniques that will help you build not only your sketching skills, but also your ability to choose what elements you want to add into your sketch as well as methods you can use to enhance or de-emphasize particular aspects of a sketch.

Shadows and Light

Identifying shadows in what you see is as simple as knowing where your light source is coming from. If the light comes from the left, then the shadows will be on the right.

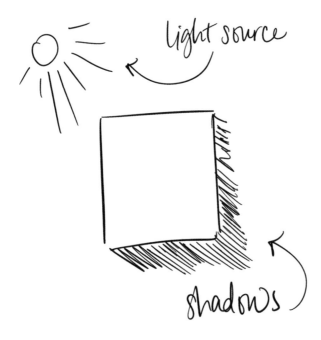

The denser your lines are on paper, the more depth you add to shadows or darker areas. Contrast is beautiful in sketching. You can choose to leave it out, add a bit, or go crazy with it. All of these styles are interesting. I recommend trying all of them to see what you like and don't like. Less is more though: you can always add but you can't take away. So build upon a piece as you work on it. I like to get through a full sketch of lines before I start to add depth because it helps me identify exactly where I want to focus my shadows.

Mark-Making

I'm not going to lay out rules for mark-making, but I do want to show you four of my favorite techniques to add depth. In general, this is considered mark-making. We're adding marks to build up density to determine how much contrast to add.

HATCHING AND CROSSHATCHING

If you've ever expressed interest in drawing of any kind, you've probably heard (or used) the term *hatching*. Hatching is essentially quickly drawn lines that are parallel and get closer and closer together depending on how much depth you want to add. When you draw them close together, they appear darker. When they're drawn farther apart, they appear lighter.

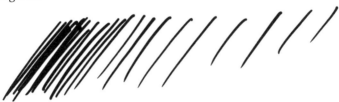

Crosshatching is the same thing with an extra set of lines crossing through the first set. Angle doesn't matter. The idea is just to build it up.

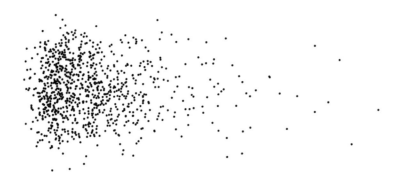

STIPPLING

If you haven't sat for an hour or five *stippling*, you might be in for the best meditative practice ever. This practice can be so satisfying because, like hatching and crosshatching, you're building up marks to create density, but you're doing so in the form of dots. Yep. Dots—as in setting your pen tip down and lifting it back up repeatedly to create a space filled with dots.

I know many people who enjoy the process of stippling more than any other part of their creative work. They find that it can be deeply relaxing and contemplative, can slow their racing thoughts, and give them back a baseline of calmness when they've lost it to the distractions and frustrations of the day.

I'll also mention that it's not for everyone. You'll rarely see a stippling sketch or drawing from me, for example, because it doesn't give me that relief. We're all wired differently, which is a good thing. It makes each of us special and unique.

EXERCISE

Practice building up marks to form various levels of density. Try drawing the marks slow and then try doing them fast. Take note of the differences and your preferences.

HORSESHOES

One of my personal favorite ways to build up marks is through a quickly drawn, unfinished circle, similar to a horseshoe. I know other sketchers who officially call these types of marks U-strokes, W-strokes, and M-strokes. These types of marks come in handy when drawing movement or small details on buildings such as siding and roofs. And again, the more you build them up, the more depth, darkness, and/or shadows you're adding. I frequently overlap this shape when drawing items I've foraged in nature, particularly the centers of flowers.

RECTANGULAR STACKS

The last mark I'll mention is one you can use to build up detail without fully adding it in. I use *rectangular stacks* a lot when drawing brick buildings. I sketch them quickly and in little sections of about three or five placed irregularly throughout the sketch. This allows me to show that there is indeed detail in the building without overloading the sketch with too much information.

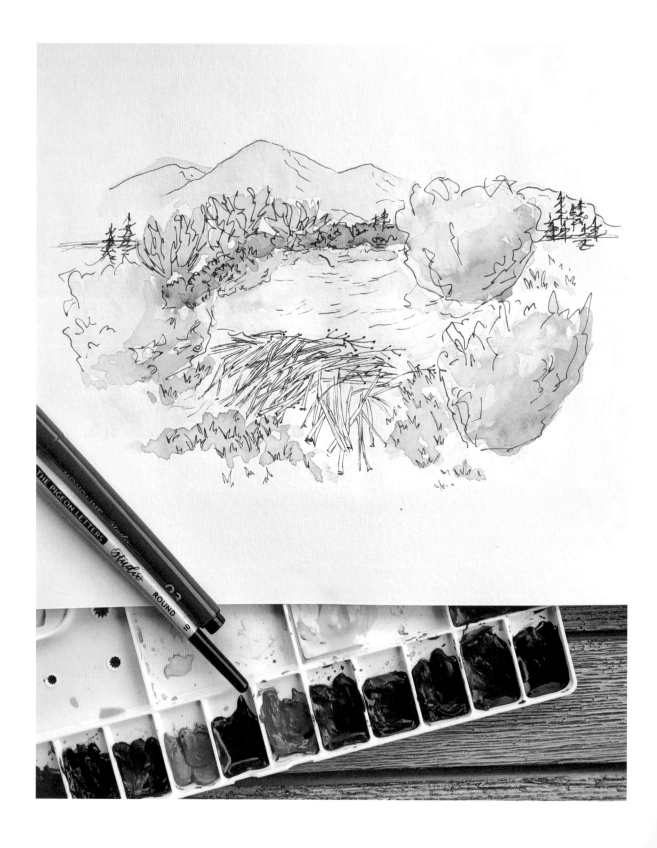

What You Sketch Evokes Emotion

As humans with emotions, we are constantly reacting to what we see, hear, feel, smell, and otherwise sense throughout our day. We have little control over the immediate impact of our instinctual reactions to this sensory input; to put it simply: we react! It takes time and effort to learn to how to exert some control over the way we respond to these external factors. This is a behavioral skill that we develop as we grow and mature—and practice.

As I began learning how to reframe and have some control over my responses to my external vulnerabilities, making art helped me. Eventually, art became one of the main methods of self-regulation that I incorporated into my daily life.

Depending on the nature of the external stimuli, I would respond very differently. Sometimes those external factors would evoke joy, but sometimes they would make me uncomfortable. A quick example to show you what I mean is music. Music can evoke many kinds of feelings in us. Some of that feeling comes from the artists who are writing the lyrics and creating the melodies and beats that make up the music—they are funneling their own very real emotions into their art and we are feeling it. As visual artists, we can do this when we sketch.

Pay attention to the next time you have a physical reaction to your surroundings and try to identify what part of your environment made you feel that way. These are some of my personal external factors that tend to always elicit a physical feeling or strong emotional response.

POSITIVE

Animals

Flowers

Old architecture

The smell of a bakery

The smell of coffee

Plants

Natural earth pigments

Unique doors and windows

Bird songs

Sunshine

NEGATIVE

Messes

Slow walkers

Someone invading my personal space

Loud music overheard on a hike or at the beach

The sound of high heels

The sound of clapping (yeah, I know it's weird)

Waiting in a line

Being too hot or too cold, being too thirsty or hungry (also what I like to call external vulnerabilities)

Clutter

The smell of garlic fries coming from the row in front of you at a baseball game just sitting there in the heat of the day (it was traumatic, okay–ha ha)

My positives might be negatives for you. For example, I love animals—all of them—and I want to hug and pet every one of them, whereas some people may feel repulsed by a stray cat or frightened if they see a rat in the back alley behind a restaurant.

One of my favorite exercises when I want to feel grounded is to take a moment to fully experience all my sensory input during a moment in time. Try it now.

Close your eyes and ask yourself these questions:

- What do I hear?

- What do I smell?

- What do I feel on my skin? Am I warm? Cold?

- What does my mouth taste like?

Now, open your eyes. Take in what you see. Don't do anything, just take it in.

Taking that moment to simply note what you see as the last part of this exercise is mindfulness. Even as your eyes overload your brain with all the information in front of you and surrounding you, you do not have to respond, you can just be.

EXERCISE

Keep a piece of paper handy as you go about your day and use it to make a list of all the sights, smells, sensations, and other stimuli that elicit an emotional response from you. Do not limit it to positive feelings—negative emotions have a lot to teach us as well. Some of your reactions might be strong and obvious, while others might be so subtle that you do not notice them until you're past the moment. But that's okay—because guess what? That's mindfulness kicking in.

Learning to be more aware of your surroundings and how they make you feel not only gives you all the benefits of mindfulness but it will also bring that much more life to your sketches.

every adventure
requires a
first step.

-Cheshire Cat

Sharing Your Passion

Your sketchbook is a personal space that doesn't judge you. It always welcomes you and it lets you carry so much of yourself in one place. Your pages are magical little gems of you. Which is a marvel, and you can keep it to yourself. But know that if you do end up sharing that part of you with others, it can open up a wonderful new world of feeling connected that you may never have experienced.

If I could summarize an ideal chosen family/community/companion in this special place that feels true and grounded and solid and supportive, it would all stem from one word: *authenticity*. I suppose it does bring in a supporting word though. In order to show up authentically, you also have to be *vulnerable*. Bringing that back around, remember that to be vulnerable is to be brave. When you are just thinking about it, it may not seem like it will feel good to expose yourself to people and show your true self. However, the minute you do reveal yourself, you will find you're almost always met in that space with the same vulnerability and authenticity. There's not been a single time I've shown up in an authentic way that I wasn't immediately met with relatability, empathy, understanding, and validation. The thing is that human beings crave humanity. It's science. We need to have an expressive outlet, and more than we need validation, we need connection.

A lot of our ability to connect with others comes from within, from first learning to connect with our own inner self. It is important to take time to look inward and explore how we feel, understand the reactions we have, the decisions we make, and our own needs and boundaries. That self-understanding is the source of feeling whole. It allows us to truly be comfortable in our own skins without feeling the need for something else to fill a void or feeling bad about ourselves from comparing our lives to that of others as we see them on social media.

The beautiful thing about showing up without filters is that it inevitably triggers a domino effect. Your vulnerability will inspire someone else to open up, then another, which will in turn move others to share themselves. Before you know it, you've found your people. You've collected a unique and special chosen family. You're being rewarded for being you, and that is so special.

Keep this in mind as you navigate staying present and being mindful about your space and time. You never know what positive difference you can make in someone's life or the impact a special moment with someone else may have on yours. Sharing your work with others and having the opportunity to view their sketches can be deeply meaningful and empowering.

Your Chosen Subject

When we're inspired to open our sketchbooks it's usually because we're prompted by some sort of inner urge—something we have encountered elicits a feeling inside that makes us want to capture the moment. It might be that we see something and experience a feeling of connection or recognition, or it might be one of those amazing moments when we suddenly see something familiar with fresh eyes.

One of the reasons that I love sketching so much is because it demands my focus to be in the here and now, which translates to a union of mind and body in that moment. I find it so fulfilling to pause in that moment to identify and unpack what I'm feeling and to appreciate my unique thoughts and responses.

When you experience the moments that prompt you to pick up your pen and sketchbook, I urge you to ponder the following questions each time. And if you want to write them down, even better. Your writing can form an active and welcome part of your sketchbook.

1. **What is the *why* in your present sketch?** The goal here is to identify how something makes you feel. When you put a name to that feeling, you can figure out what it is about that special something that invokes those feelings within you.

2. **Why does your chosen subject matter to you?** Try to explain why it feels significant.

3. **How does your chosen subject bring new light to your present moment?** What have you noticed that you may not have seen before?

4. **What are you saying through your present sketch?** It might not seem apparent at first, but sketching is a form of communication with yourself. Sometimes it's also intended for additional eyes. But the most important part is your personal journey and how you connect with your process.

As we've discussed, there is truly nothing off-limits when it comes to sketching. I want to introduce some of my personal favorite subjects to sketch in hopes that one of these creates inspiration for your own practice.

Architecture

There are so many examples of magnificent architecture, and I'm willing to bet that they all originally stemmed from a feeling. We all have personal favorites—and the way a particular style makes us feel when it's presented is why we like or dislike it. Naturally, many types of architectural features come from the elements and environment that they're in (known as vernacular architecture). If you think about your own reaction to an architectural style more deeply, you may find there is more to it than just a visual response. Maybe the reason you're attracted to an adobe or stucco house is not just because of how it seems to belong to its environment but also because of the feeling you get when you're in a beautiful desert filled with sunshine and blooming cacti. That's significant and that energy will translate into your sketch.

Some other styles of architecture may transport us into a land of fantasy. Think about a castle, for example—in that case, for most of us, any experience we've had with that style of architecture came from beloved childhood books or movies.

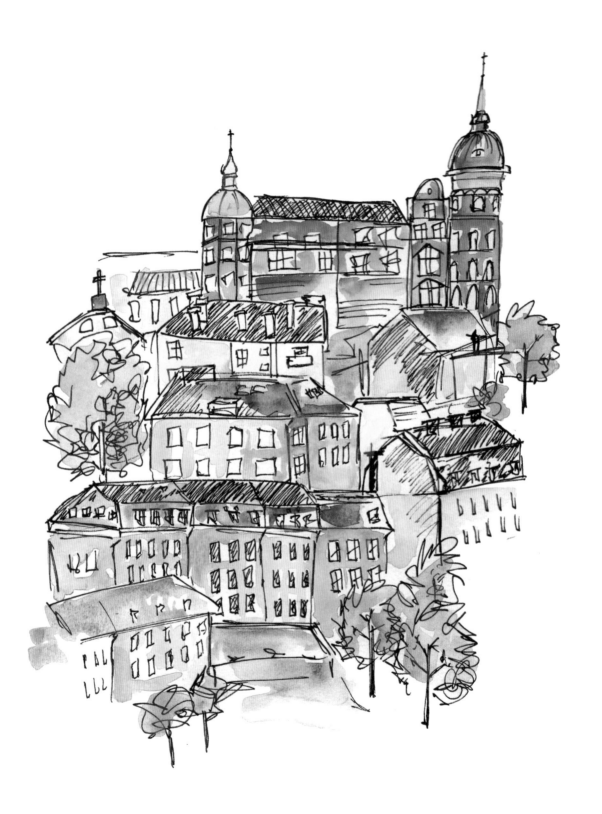

As you encounter different styles of architecture, think about the feelings they evoke in you. I say "feelings" instead of listing adjectives because we all know how to describe a building, but sometimes those words get in the way or block our feelings. For example, modern architecture is clean and minimal, but what feelings does it evoke? Some may feel bored by it, while others may feel refreshed when looking at it.

What feelings come to mind as you view the following architectural styles?

- Industrial (lack of ornamentation, flat roofs, clean lines)

- Gothic (very tall, intricate, stained glass)

- Baroque (dramatic, curvaceous, luxurious)

- Art Deco (sleek, linear, curved, geometric)

- Victorian (dollhouse style with elaborate porches, ornate roofs, arched windows)

- Tudor (exposed wood framework, steep gable roof, large chimney)

I want to say that I selfishly used that exercise because I am personally so enamored with architecture, but truthfully, it's a helpful exercise to sketch your surroundings and embrace not just what you're drawing, but why.

You can apply this same exercise to everything else you choose to sketch.

Food

Food is a great subject for sketching because we interact with it daily and tend to have strong, easily identifiable feelings about it. Think about a platter of fruit versus a platter of meat, cheese, and crackers. Each gives off a different feeling. The fruit likely evokes a sense of freshness while the cheese plate might give a sense of fulfillment. Why do you think so many cheese plates include fruit, meat, dipping sauces, and the works? Total satisfaction.

Let's walk through how you can break down a still life scene. Ideally to really capture the energy of something for a still life, you want to have your chosen subject right in front of you, but for the sake of walking you through this, I'll be using a photograph.

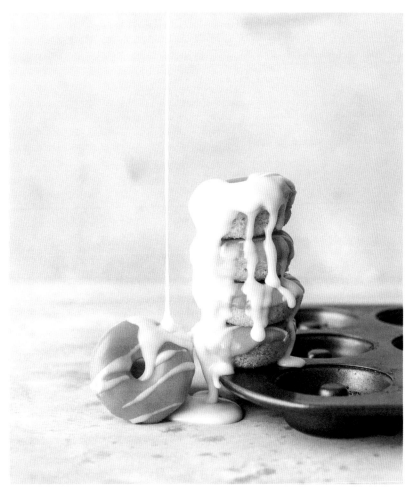

This image was taken by a photographer and teacher and friend of mine, Tabitha Park, who has kindly let us borrow it for reference.

The first thing I notice is the beautiful drips of frosting. But thinking about breaking down things into shapes, I focus on the wavy lines of the frosting in contrast to the circular form of the doughnuts. Because the frosting covers a lot of the doughnut shapes, I'm going to work backward on this piece. There's nothing wrong with sketching the stack of doughnuts first. I'm just choosing to work this way because I can ensure that the drip comes out how I want it to look since that's what I've chosen as my focal point.

You can see that the frosting is a big chunk of space that combines all the doughnuts, so I'm going to draw that in first by following the curves of the exterior lines.

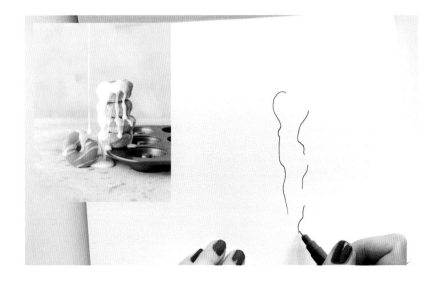

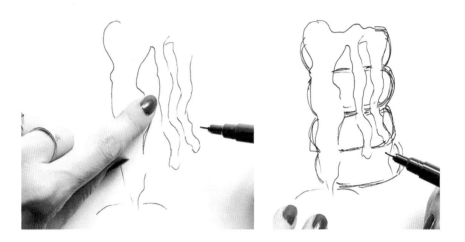

I've continued sketching the smaller drips of doughnuts, and the main thing I'll point out is that I've included curves in them that will be at the edges of the doughnuts. So the curves that push to the right will be hugging the sides of the doughnuts. Make sense?

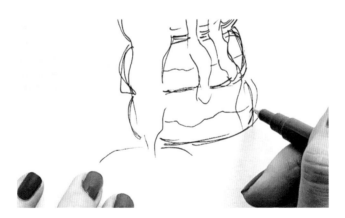

You'll notice that the doughnuts also have a first layer of maple frosting, so I've added in some additional imperfect lines through the middle of the doughnuts.

From there I'm adding shading on the bottom side of the doughnuts to create some contrast and depth for shadows. This helps to make the doughnuts stand out more.

Moving onto the circular doughnut facing outward, rather than starting with the frosting, I want to draw the circular shape first to ensure that I have the size comparable to the doughnut sizes in the stack. This is just the way that my brain works and it's not necessarily the right way or the wrong way. I've left a bit of open space for the frosting to drip into it.

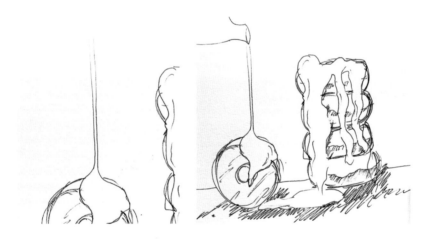

To add the frosting drip, I've created two straight lines by flicking the tip of my pen toward the ends at the top so it appears that it's continuing off the page.

Alternatively, you could draw the drip coming from a pour spout or pitcher to give even more energy to the scene, making it more interactive.

Flowers

Let's get into nature! Flowers are among the most rewarding things to draw (which is why I have published several books on how to draw and paint them!) They bring life into any space with their delicacy, colors, vibrance, and smell—which may be why so many of us who start drawing flowers can't seem to stop. I also find that capturing nature on paper really boosts that special organic feeling of a hand-drawn sketch.

Nature itself is perfectly imperfect, so it's the ideal subject for embracing the art of imperfection. If you really look, you will see that nothing in the natural world is perfectly symmetrical. In fact, the more perfectly we try to draw flowers, the more they end up looking like doodles. While that's not necessarily a bad thing, I want to encourage you to sketch botanicals in their wild forms. Let's start now!

I'm going to begin with a simpler form to acquaint you with some petal shapes that aren't too complicated. When I first began drawing flowers, gerbera daisies were the subjects that I drew over and over because their simple, repeating forms allowed me to focus more on structure, which was very helpful for a beginner botanical sketcher. Before long I was ready to move on to more leggy, unpredictable wildflowers.

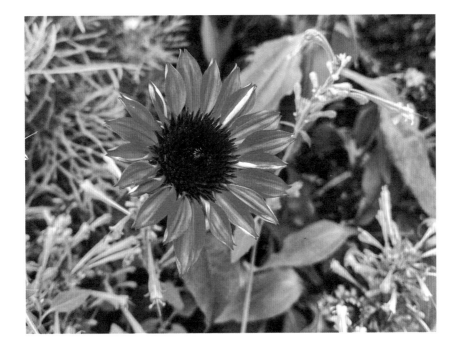

For this exercise, I'm going to use a red coneflower, or echinacea, from our backyard, snipped from what's become a miniature meadow of bright, beautiful colors, thanks to my wife's love of flowers. With lots of petals and a spiny disk in the center, it has both form and texture that make it a good choice to sketch.

I like to start with sketching the center of my flowers first. You can do this by drawing loose circles or horseshoe shapes, or even just a stippling style as I've chosen to do here. The more marks you make in one spot, the more depth it will add to that area.

Once the center is drawn, I begin adding petals. Now, if you've ever drawn a flower and you start drawing petals around the flower just to realize at the end that they kept getting shorter and shorter as you drew, you're not alone! This happens to all of us. That's why I suggest choosing a few spots at different locations around the center to place your first few petals before filling them in all the way around. This trick also allows you to use the length of those initial petals as a guide for the rest.

Notice that the petals are very loosely drawn. I don't worry about creating a perfect structure. Instead, I'm focusing on the general petal shapes, and interpreting what I'm seeing in order to translate it onto paper. In this case, the petals are narrow at the base where they meet the center of the flower. From there, they widen, and then come back in toward the tips.

You'll also notice that I've created a textured V-shape at the tips to translate the petals from the echinacea to my sketch.

As you fill in all your petals, try not to space them out perfectly or fill in every single gap. It will end up looking like a circle and diminish the natural look that you want. When you can find opportunities to be intentional with leaving gaps or unfinished areas, you actually are adding to the naturalistic feeling—think of it as building the flower's character. And as always, remind yourself throughout the process to release your expectations of perfection or of making your drawing conform to a preformed image in your mind.

When it comes to adding details, I like to touch my pen down and apply a flicking motion so that as I lift it off the paper, the end of my stroke is lighter and thinner. I do this with the details in petals, but I'm also careful to make sure that they follow the natural direction of the petal's shape. So you'll see that I've drawn the interior lines as curves as well. They're also staggered in height and in how they're spaced out. You want to avoid anything too even or overly symmetrical or it won't translate as well.

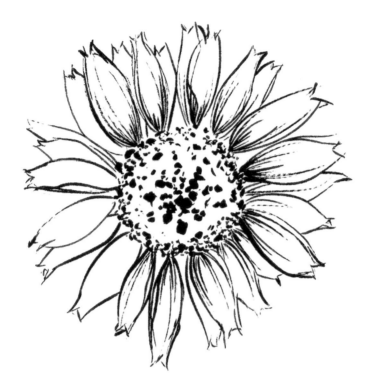

Lastly, I love using marks to give a sense of depth to the petals and the central disk of the flower. Notice how it's darker around the circumference of the middle, along with the connection to the petals? This is because I created more marks at the base of where the petals connect to the center so they look more like they're tucked into it rather than sitting next to it. Simple tricks like these will bring your nature sketches to life!

I could keep going and create a long list of objects to sketch, but I want you to trust your intuition. If you look over and you see a stack of your favorite books and it makes you feel warm and content, document that feeling by taking a picture with your hands, a pen, and your sketchbook.

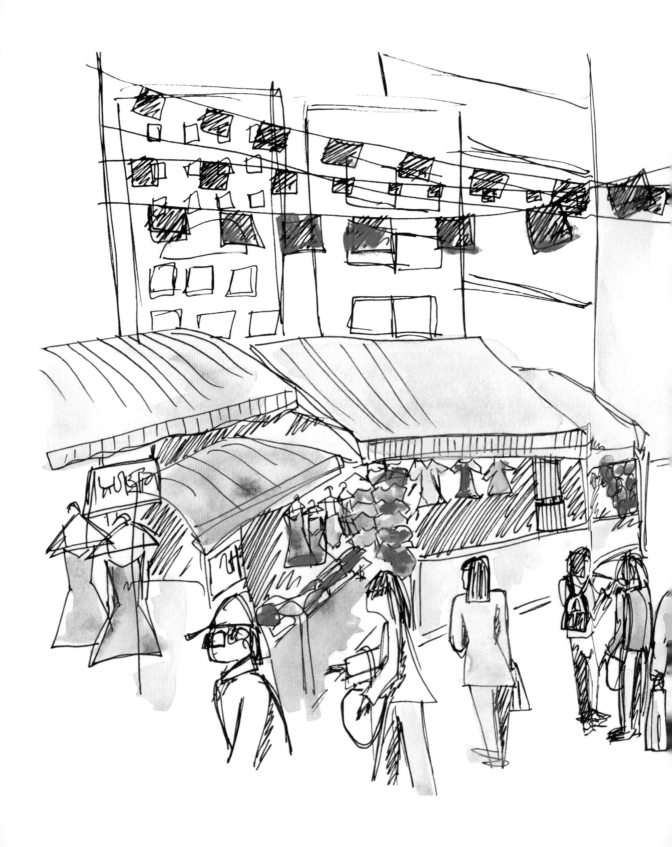

Techniques for Sketching People

Let's say you do want to include people in your sketches. That can be a whole other thing that makes you freeze up just thinking about it. For some of us (my hand is raised high), people can be the trickiest subject matter to approach in sketching. This is most likely because people are so familiar to us and we lack the confidence in our ability to accurately represent them. Remember, though, we're not trying to make our sketches perfect. We're not even trying to make them fully accurate. Especially when it comes to perfect people and proportions. Learning some rules and tips for drawing will help overall, but the goal is to loosely sketch and capture energy as it arises. I'll share some tricks that I've learned over the years from other sketchers and also from trial and error (a lot of it!).

Tip 1: Draw people's heads near the eye-level line. Their head positions may vary above or below that line according to their height, but you want to make sure they always line up near there. Knowing this will help you set yourself up for better accuracy.

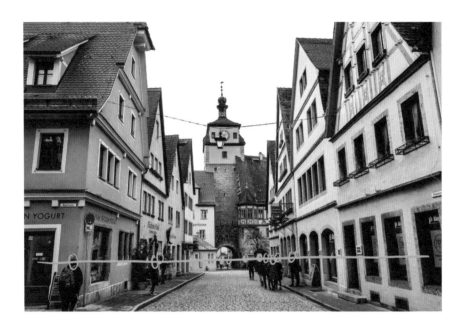

Tip 2: A person's head equates to an eighth of their body. Their torso equates to three-eighths and their legs equate to four-eighths. I say that instead of half because if we draw these fractions as individual circles, you'll easily see how balance is formed. Following these equations, once you've drawn the head of a person, you're good to go for the rest of them.

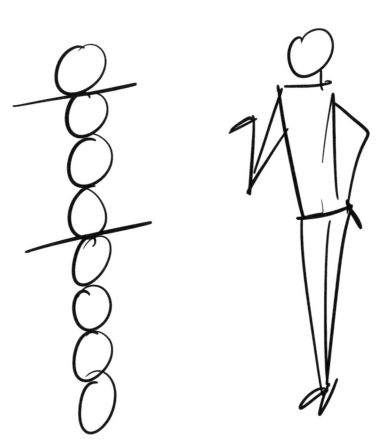

Tip 3: People are also made up of basic shapes. You don't need to worry about drawing perfect curves, anatomically correct hands, proportionate torso-to-leg ratios, or representative faces when you sketch. In fact, I don't draw faces on my people at all. I choose this not just because I'm terrible at faces (true), but because I'd rather capture the energy of people rather than draw attention to their individual features in the sketch. They are part of my scenes but not the focus of my scenes, and for some reason, I feel like the minute eyes get involved, that's where we look. But just because I make the choice not to doesn't mean you should follow suit. Just know that as you sketch, these details aren't as important as your brain may try to tell you that they are.

Let's sketch a few characters together.

Heads are simple. You know how to draw a circle or an oval. Draw two lines coming from the circle for their neck. For this person, let's do a young student who has perhaps just left class. They're wearing a backpack, T-shirt, jeans, and sneakers. I'm also going to draw them from the side.

From the neck, we can create a small C-curve for the collar of the T-shirt, then either straight lines that point downward or curved lines for more pronounced shoulders. I much prefer to make quick lines that allude to clothing styles, so I'm drawing fast, straight lines. From there I can complete the T-shirt by drawing a rectangular shape. You can see from my sketch that I moved my pen quickly, without a lot of attention to forming the lines. I do this on purpose so that I don't get hung up on details and I can commit more to embracing imperfections.

Pants can also be drawn with quick lines. I like to taper them at the bottom, but this is a stylistic choice and I suggest playing around with different styles until you find one you like. For the sneakers, I'll create small, curved shoes with flat bottoms, then overaccentuate the loops of the laces to clearly indicate a tennis shoe style.

How I draw the backpack will depend on the position in which I've drawn the person. For example, this sketch shows them facing sideways, so I'll create an oblong shape on their back and perhaps a small line on the front to show a backpack strap. If they were facing toward me instead, I could simply draw two straps on the front of their shirt and maybe a small curve popping out from behind them.

Not too difficult, right? Let's sketch another person. This time, I am going to put them in shorts, a cardigan, and a hat, and they'll be jumping in the air. The same techniques (or lack thereof) apply for each person we draw. It's simple lines and shapes that change. Let's walk through this one together.

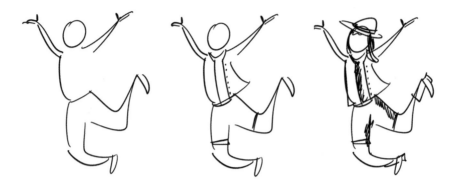

First, draw the round shape to create the head, then add lines for the neck. Since this person is jumping, I will alter the curve in their body. Their torso will have a slight bend to it and their legs will be bent at the knees.

Notice that I drew the torso in without worrying about any potentially overlapping lines when I add in the cardigan. Remember our mantra? *Embrace imperfection.*

To add the cardigan, I'll draw two rectangles on each side of their torso, add sleeves, and add buttons to one side.

Adding shorts is as easy as drawing a simple line at the length of the shorts within their legs. See the difference a simple line can make?

Choosing hat styles can be fun. Sometimes I'll see someone I want to capture in a sketch and I'll opt to completely change the style of something they're wearing based on someone else I see. Sketching allows us to combine different things that we see in order to record what stands out to us most.

For this person, I've chosen a sunhat because they are so recognizable. You can draw a simple line or shallow oblong shape and add a C-curve to the top of it.

From there, add any shadows or other details you want.

EXERCISE

Sketch a few people with unique characteristics. I'll give you
a couple of prompts to get you started.

PROMPT

Person with stroller wearing leggings, a hoodie, earbuds,
and a ponytail.

PROMPT

Someone wearing a summer dress, sunglasses, and sandals,
sitting down and holding a summery drink.

PROMPT

Your choice! Choose an outfit, an accessory, and a pose or activity.

As you can see, all of these people have something in common.
Every single detail, from their body shapes to their clothing to their
accessories, all present in simple shapes and lines. Keep in mind the
simple tricks we went over as you draw, and it will all come together.

Now that you're comfortable with drawing people, it's time to try building a scene that includes some people. Don't worry—I'm going to walk you through it.

Remember the first tip that I gave you: People's heads are always drawn near the eye-level line. Their heads may appear above or below that line according to their height, but they always line up near there. Let's also opt to sketch in the people first—starting the scene with the people helps us to capture their special energy and will make them more of a focal point.

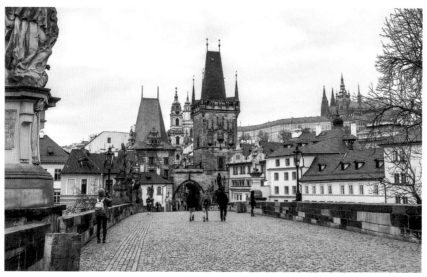

This photo of Charles Bridge in Prague was taken on a brisk winter morning late 2017.

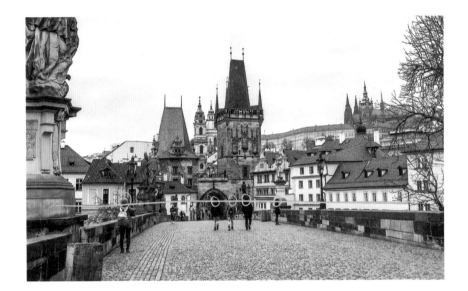

Don't panic—at first this scene might seem a little tricky since the view is on a bridge and the ground slopes downward and then directs upward again just past the tunnel. But remember, no matter what, the horizon line always remains at eye level.

Now let's walk through what we know—those fundamentals really do us a favor here.

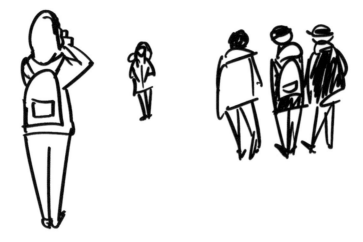

As previously mentioned, the people closest to us have their heads along our eye level, but their bodies get smaller the farther away they are. Since we'll be sketching people first, we'll incorporate these details right away.

Recalling the head-to-body ratio (a person's head is approximately an eighth of their body), after placing their heads along my eye level, I can record their bodies and choose what accessories I'd like to include to better personify these strangers and make them feel more familiar.

The person on the left has their hood up, showing that it's chilly outside. They're carrying a backpack and taking a photo of the old city. They're doing their own version of recording this magical place to remember for years to come. See how these three details tell a whole story?

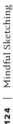

Once these main people are in the sketch, we can build the scene around them.

Let's look back on these sketches now. How can you answer the questions I prompted earlier about what can be felt through this sketch? People bring so much life into sketches, especially when exploring a city.

Sketching Prompts

Believe it or not, you're ready to fully dive in. You have the foundation to begin and build upon your sketching practice, and like anything, the more you practice, the more you'll build muscle memory.

It's always hard to jump into a new skill—but I believe you will find that doing so with imperfection in mind is at once less daunting and more fulfilling—this is not a typical approach when you're learning something new. In fact, trying to be imperfect on purpose may seem the precise opposite of everything that you have ever learned about how to develop a new skill, where swift mastery is usually the goal. So think of it like this instead: I'm giving you permission to play. I'm giving you permission to mess up. I'm giving you permission to embrace imperfections.

We'll start with a couple of exercises you can use to warm up, and then I'll share some sketching prompts that you can use to practice your new-found skills.

Blind Contour

Let's loosen up with what might be my favorite sketching exercise of all time. Blind contour drawing is a staple of art schools, a long-practiced exercise that is set up to allow the sketcher focus on a particular object without focusing energy on how they're re-creating it. It is particularly freeing because it allows our eyes to communicate directly with our brains, which then communicate with our hands, all without us ever glancing down at the image. This is a true challenge because it feels so counterintuitive—and just wrong—to not see what you're drawing. That's the idea though!

Blind contour drawing is all about developing your observation skills and connecting with your subject. Instead of worrying about your work looks like, you're really looking at the object you're drawing. You have to slow down, and you have to stay in the moment. And you can't be self-conscious or judgmental about how you're doing when you're not allowed to look at your work.

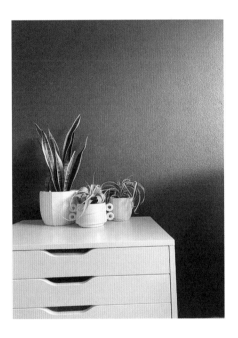 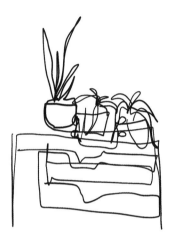

So sit down, put an object in front of you, hover your pen above your paper, look up at the object you chose, and begin to draw. *There's one rule: You can't look at your paper until you've completely finished.* If you really want to challenge yourself, try doing continuous blind contour drawing, where you can't lift your pen.

Do you feel a little more loosened up? Perhaps you had a little laugh at the final drawing when you finally got to see it?

If it makes you feel better, my plants sure don't look like plants.

Let's continue . . .

Three-Minute Timer

You'd be surprised how much you can sketch in only three minutes. The first time I did this exercise, I was on a work trip and had only ten minutes before I needed to leave. My urge to create something—anything—was nagging at me but I just hadn't had the time. I didn't have my favorite pen to draw with and instead only had a bold felt tip pen. I decided that I had made enough excuses and I had to let it out, so I stood at the window and sketched the building across from me. Let me tell you, to my surprise, three minutes turned out to be more than enough time, and afterward I felt rejuvenated. Was I happy with the finished product of my sketch? Not particularly. But it didn't matter because what I needed more than anything was to allow myself to play, even if only for a few minutes.

Set up a timer and challenge yourself to show up for a whopping three minutes. You might surprise yourself.

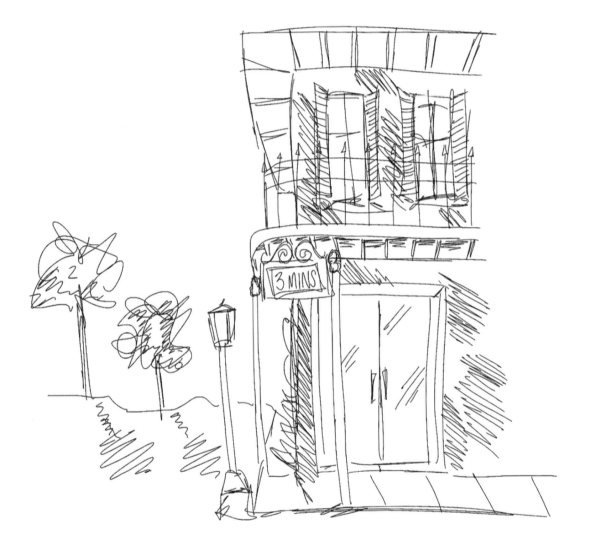

Note: If you can make a three-minute plan each day, your sketchbook
will be full of surprises!

Comfort

Sketch something that brings you comfort.

I think it's safe to say that comfort means a lot of different things to people. Some of us may find comfort in the obvious, like slipping on a cozy pair of socks, snuggling into a warm blanket next to a roaring fire, sipping a steaming beverage, and so on. Insert hygge.

Other forms of comfort might be invisible, but still effective, like staying in your comfort zone. What does your comfort zone look like? It might be a behavioral trait (like shyness or waiting to hear someone else's ideas before you share your own), a daily routine that you follow (going for a walk every morning), engaging in a particular hobby (could it be sketching?), even the food you choose to eat (a grilled cheese sandwich at your favorite diner).

What about when you're sick? Comfort could be a warm humidifier and a box of soft tissues, and best of all, your favorite sheets *(looking at you, stonewashed linen)*.

It could be your morning tea or coffee. Every morning, I look forward to my first cup of tea. Sometimes before falling asleep, I literally mention that I can't wait for tomorrow morning because I love that moment so much.

Maybe you find comfort through the people you love. Your BFF or your partner could be the ultimate comfort. Their presence gives you strength and a feeling of belonging.

Perhaps it's a favorite place? Somewhere you can go, a quiet corner or a wooded path, where you feel calm and comforted?

When you think about comfort, what stands out to you? This prompt, if you haven't guessed yet, is to sketch your very own comfort zone.

Excitement

Sketch something that makes you feel excited.

Excitement looks different for everyone. I get incredibly excited about traveling, so it would be the perfect scenario for me to sketch a scene of the departure gate as I wait to board an airplane. I've even sketched the interior of a plane a time or two.

You might get excited about going to a loved one's special event, such as a play or recital in which they're performing. It could be one of your favorite basketball team's home game (also a sketching opportunity I've taken advantage of).

For me, sketching is magically both mindful and, in a way, mindless. What I mean by that is, I can empty anxious energy into a sketch, which keeps me present and grounded in my surroundings, yet also helps me get out of my head a little. It can be so easy to get trapped in there, you know?

Release some of that energy when you're feeling excited for this prompt.

Learning

Sketch something that you want to learn more about.

Can you think of something you're attracted to but don't fully under-stand? Maybe it's something in nature, such as trees or birds. For some, cooking and baking are big ones. There are so many fun, tasty-looking new recipes to try and lovely presentations of the finished dishes. I've had a few students who have gone on to create wonderful recipe cards from their food sketches; they're so lively because of the style and energy that comes from the sketches. Insert broken record here: *embrace imperfection!*

Think about something that draws your interest that you'd like to learn more about and use it as a sketch study.

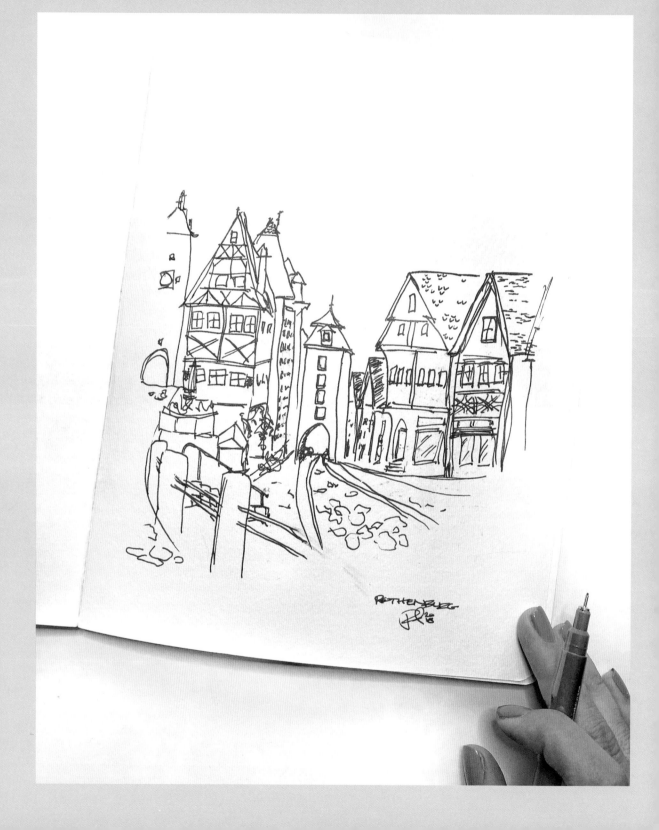

ROTHENBURG

Redefine Completion

I waited to talk about the idea of finishing a sketch until now because I wanted to allow you to go through some rounds of practice first. You could take my word for it, but practicing is really the best way to begin to truly feel the intuitiveness that sketching brings out in each of us. Yet because I have personally struggled with knowing when to stop, I wanted to bring it up with you and hopefully help you with it as you continue your sketching practice.

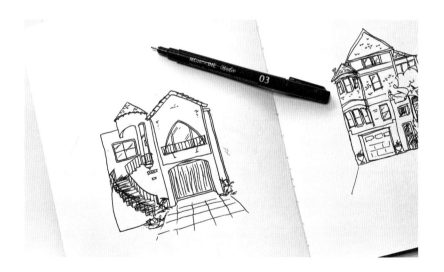

Let's be real here. A lot of us overthink. Even if you're not an obsessive overthinker, I'm sure you still overthink some things. It's our nature as humans. So while you may have finally accepted (and I hope you have) that you're embracing imperfection, when you look at your work, you might not feel like you love your sketches. Maybe you feel like something might be missing or that it's somehow just not . . . done.

Are you ready for a total mind shift? It's probably not that the sketch is missing something, but rather that it's been overworked. Seriously. Too much detail is too much detail. About those bricks . . . You really, truly don't need to sketch each and every one of them.

So how do you know when a sketch is finished? This process is intuitive and you will learn to trust yourself the more you sketch. I can't determine this part for you because one of the beautiful things about our individual creativity is that we learn and grow the more we spend time in that space within ourselves. That means that we have the luxury of making creative choices, including when we consider a sketch finished. Most of the time our finished results will give us input and guidance on the creative choices we'll make the next time, and then the time after that, and the next time yet. Trust the process and remember that overthinking can cloud your organic joy. Stay present with yourself and trust your intuition as you continue sketching. Focus on the process. You'll begin to learn to intuitively know when you're finished.

trust
the
process

Your Unique Style

If you've read some of my other books, you know that I often speak of "owning your unique style." If sketching is new to you but other art forms aren't, I have some good news for you. No matter what your style is in your other creative practices, sketching is kind of like handwriting. Each of us has our natural style. We can certainly add or subtract details and be choosy with what we decide to include in our pieces, but our style comes from within us—it's innate and intuitive instead of something practiced and learned. Your style is natural and immediate when you start sketching. Isn't that interesting? Once you have a solid understanding and have practiced perspective and basic shapes, *the rest is all you*. You can make decisions to refine your pieces, but as you saw in earlier examples of sketches from different artists, they translate uniquely. Guess what? Nobody can sketch exactly like you can. Not only is your creative impulse special and organic, but the work that emerges from it is too.

Presence of Mind

Remembering that this is a mindful practice, it's so important that we give ourselves grace, not only in our creative practice, but also in our humanity. Throughout our lives we will mess up, make mistakes, and fail at times. We'll falter. We'll hurt someone's feelings. We'll act destructively. We'll get angry, probably angrier than we want to get. We'll say hurtful words and lash out. We'll feel defeated sometimes. And sometimes we'll just feel numb. Remember that all of these feelings stem from something. Anger is often a secondary emotion to sadness—it can be easier to be angry than it is to be sad. Anger comes out as adrenaline and can feel powerful, while sadness turns in on itself and can feel empty and hollow. The thing to remember is that though a particular feeling may not feel good, it will pass. You don't have to do anything with it. Emotions are temporary and they're wonderful tools for self-knowledge if we can learn to think about and choose how we respond to them. But first, we must identify what they truly are.

You've probably seen a chart of silly illustrated faces that represent different emotions. These are often used when adults are trying to communicate with children to help both sides understand and assist with how a child is feeling. I want to tell you that these charts are actually great tools at every stage of life. Here is why: Let's say you are feeling sad, but that word feels too general to really describe or explain all that you are feeling. You need something more descriptive. I am going to give you a detailed list that you can use whenever you want to really identify how you're feeling (see page 144). I have found it tremendously helpful in bringing myself back to my reality.

You might be wondering why I'm putting such a focus on words in a sketching book. I'll bring it back to my truth and the reason that brought me to writing this book and sharing it with you. Creativity is only one part of what has helped me to stay mindful and present and show up confidently in the world. In fact, my creativity acts as a bridge for me to be able to express how I'm feeling. In the heat of the moment, I haven't always been good at articulating my thoughts and before I developed better coping skills, that would be the prime time that I would lash out. Even at this very moment, I'm able to identify that sharing this with you is making me feel shame and embarrassment, but also vulnerability, and in that vulnerability, there is power. Because I can show up and hope that in some way, something that I'm saying might resonate with you, my readers. That in some way, practicing mindfulness will help you as it has helped me.

Emotions that we don't process well can cause us to act in ways that are against our better judgment or self-interest. However, sometimes if we can press pause and stop the urge to act on the situation while we find ways to soothe our emotions and return to our baseline state of calm, we can face the situation with a clearer head and make better choices. Being able to acknowledge but not act on a feeling in the moment is mindfulness.

When strong emotions are triggered, give yourself a moment to breathe, gather your thoughts, and self-soothe—because triggered people don't think clearly. It's that simple. Mindfulness can prevent a lot of damage.

It can also help us to connect more deeply with ourselves. That in turn makes us better able to communicate our needs and connect more fully and rewardingly with those we care about.

This is not to say that you shouldn't feel things. As I said back in the beginning, you should feel all the feels! Just as we must at times feel all the negative emotions I mentioned, we will also feel positive feelings such as joy, satisfaction, and gratitude. Without darkness there is no light. Allow yourself to feel your emotions and welcome them in. Exist within that emotion as you need to, just don't let that emotion exist within you. You're bigger and stronger than a temporary feeling.

I could dig so deeply into this subject that I could talk about it all day. You might be surprised that these words are coming from a person who initially ran from these ideas. Now I can't stop talking about them. If I can benefit so much from living and practicing a mindful life, anybody can. Your experiences matter. Your story matters. Your feelings matter. Your growth and progress matter. I'm so happy to share this part of myself with you, even when it's hard. Thank you for supporting me even by reading these words. Now let me support you by providing you with a few tools that may help you feel stable, creative, and inspired.

Press on, my friend! (I don't really know what that means, but it felt timely to say it.)

abandoned	cheerful	distressed	frustrated
absent	clever	disturbed	fulfilled
absorbed	cold	dominant	full
accepted	compassionate	down	giddy
aching	compelled	doubtful	gloomy
afflicted	competent	driven	greedy
afraid	concerned	eager	gleeful
aggravated	confident	ecstatic	grouchy
aggressive	confused	edgy	guilty
agonized	content	elated	happy
alert	courageous	embarrassed	hateful
amazed	cozy	empathetic	heartbroken
amused	critical	empty	hesitant
angry	crushed	enamored	hollow
annoyed	daring	enchanted	hopeful
anxious	delightful	engrossed	hopeless
apathetic	dependent	energetic	hostile
ashamed	depressed	enraged	hurt
attached	desperate	enthusiastic	indecisive
attracted	determined	euphoric	independent
awkward	devastated	excited	indifferent
balanced	devoted	exhausted	influenced
bewildered	disappointed	expressive	impatient
bitter	discouraged	fascinated	impulsive
blissful	disinterested	fatigued	inquisitive
bored	dismayed	flustered	inspired
centered	disoriented	fortunate	interested
certain	distant	free	introspective
challenged	distracted	frightened	irrational

isolated	panicked	secure	understanding
jaded	paralyzed	self-assure	uneasy
jealous	patient	self-conscious	unique
joyful	peaceful	sensitive	unsuccessful
jubilant	peppy	sentimental	vain
judgmental	picky	serene	victimized
lackluster	playful	shameful	vulnerable
liberated	powerful	significant	warm
lonely	proud	silly	wary
lost	provoked	small	weepy
loved	quiet	sorrowful	whole
lucky	radiant	spellbound	wishful
lustful	rebellious	spiteful	withdrawn
mad	receptive	stimulated	woeful
manic	refreshed	stressed	worried
melancholy	rejuvenated	stubborn	zealous
moody	relieved	subdued	zestful
motivated	remorseful	submissive	
moved	renewed	successful	
mournful	resentful	surprised	
neglected	reserved	tenacious	
nervous	resilient	tender	
neutral	restless	tense	
open	restored	thankful	
optimistic	revived	touched	
outraged	sad	tranquil	
overjoyed	safe	triumphant	
overstimulated	satisfied	trusting	
overwhelmed	scared	uncomfortable	

mindfulness

↓

awareness

Resources

Mindful Sketching Resources

Visit me at ThePigeonLetters.com for weekly art tutorials and videos and to grab tons of freebies, and even watch a few of my classes!

Be sure to check out some of my favorite sketchers:

- Felix Scheinberger @felixscheinberger (Instagram), author of *Dare to Sketch* and *Urban Watercolor Sketching*

- France Belleville-Van Stone @wagonized (Instagram), author of *Sketch!*

- Ian Fennelly @ianfennelly

- James Richards @JRsketchbook (Instagram and Twitter), author of *Freehand Drawing and Discovery*

- Ohn Mar Win @ohn_mar_win (Instagram)

- Riona Kuthe @anoirpics (Instagram and Twitter)

- Samantha Dion Baker @sdionbakerdesign (Instagram), author of *Draw Your Day*

Mental Health Resources

MEDITATION

Here are some proven meditation methods that are used by therapists and have scientifically proven benefits, including mindfulness meditation, focused breathing, and muscle relaxation.

For each of these, you want to find a comfortable, quiet place to sit, in a position that is relaxed but not sleep-inducing.

In **mindfulness meditation** you watch your thoughts and feelings as they come into your mind as if they're on an assembly line. You don't react to them; you simply look at them as they come and go. This is not as easy as it sounds, but with a little effort, you can do it. Sometimes it helps if you visualize your thoughts and feelings as clouds passing by. By calmly watching thoughts and getting used to the idea that you don't have to react to them, but can just let them be, you can develop strength and resilience. You will start to find that you have the ability to change all-or-nothing beliefs and reactive behaviors that are not helpful to you.

Focused breathing is a helpful skill that everyone can benefit from learning. When you are experiencing distress, breathing often becomes shallow and quick without you even realizing it. That rapid breathing is your body telling your mind that you're upset, and it can lead to you quickly losing your cool. Focused breathing can restore your sense of calm. There are many different methods for focused breathing, but alternate nostril-to-mouth breathing on a four-count is my favorite breathing exercise. Here is how you do it:

- Slowly counting to four on each inhale and exhale, breathe in through your nose and out through your nose four times

- Still counting to four on each inhale and exhale, change to breathing in through your nose then out through your mouth four times

- Continuing to count to four on each inhale and exhale, switch to breathing in through your mouth then out through your nose four times

- Lastly, counting to four on each inhale and exhale, breathe in through your mouth and out through your mouth four times

- Repeat as needed

Progressive muscle relaxation is a whole-body relaxation exercise that involves gently tightening a muscle group, pausing, and then releasing to rest while slowly exhaling. You can start with your head or your toes, then move through each part of your body. This is a calming technique that also helps us feel present in our bodies.

OTHER THERAPEUTIC METHODS

If you are interested in great self-awareness and learning some tools for emotional well-being, here are some to check out.

Cognitive behavioral therapy (CBT) is a psychotherapy practice that is based on the idea that our thoughts and behaviors influence our feelings. It was created by Dr. Aaron T. Beck to help change the way people think about and react to situations to increase their overall mental and physical health.

Dialectical behavioral therapy (DBT) is a more structured practice that I was fortunate enough to learn in my late twenties. What I love most about it is that it gives me tools to slow my racing thoughts and be more aware of my external vulnerabilities, so that I can then change my responses to any pressure I feel. It's a form of therapy that was created by Dr. Marsha Linehan, and it is chock-full of helpful acronyms that help you to remember the steps for understanding your feelings. The easiest to remember is STOP. If we remember to STOP when we're feeling triggered, we can take the time we need to regulate our emotions.

It's essentially a tool that allows you to pause and take a breath while remembering why you're pausing. I know it seems simple, but in the heat of the moment, thinking through "stop, take a breath, observe, and proceed mindfully" is extremely helpful. The observe step is what really got me. I used to be pretty aware of when I needed to take a step away and take a breath, but that's all I did. I didn't process anything or try to determine what was making me feel a certain way or even what had triggered me. I'd just distract myself so I didn't feel the uncomfortable feeling anymore. But observation is a key part of it. Observing means being aware of everything going on in that moment. After stopping and pausing, consciously being aware of your emotions and your thoughts, and recognizing them as exactly emotions and thoughts rather than facts can be quite the awakening. It helps bring you back into your rational mind.

S - stop
T - take a breath
O - observe
P - proceed mindfully

It's also helpful to observe how emotions are affecting us physically. It turns out that naming these emotions and physical sensations can have a calming effect. Once you have identified and named your emotions, you can proceed mindfully—that means that you've gathered your thoughts, dismissed your false beliefs, and self-soothed. Now, no longer in the heat of the moment, you're capable of thinking healthily about what to do. I could go much deeper into this, but I want to simply open this door for you to actively discover more about what makes you tick. We're all perfectly unique in how we interact with what we see and feel—and that doesn't have to be a bad thing.

These are the tools that have helped me over the years; they have been useful not only in addition to my creative practices but have helped me with my creative practices—it all works together. Doing self-work isn't always easy, but it is the most rewarding experience I've ever had, and I wish that for you too. If you do feel like you'd like to continue to deepen your therapeutic practices and want to explore more options, I recommend following up with your doctor.

Additionally, here are some websites that I recommend perusing as you deepen your journey in mental health.

- National Alliance on Mental Health (NAMI.org)

- Association for Behavioral and Cognitive Therapies (ABCT.org)

Acknowledgments

It's difficult for a lot of us to pause in such a busy, digital-focused world. I want to take a moment to share my gratitude to some very special humans who have helped my busy mind pause:

Laura—You are the best person I know and I would never have reached this elevated place in my life without you, so thank you for challenging me each and every day. Thank you.

Dad—You are just as bad as me at slowing down, ha ha. But what you're really good at is finding golden moments in little experiences, and my eyes are always curious because of you. Thank you.

Mom—I miss you every single day. You put me into all sorts of creative outlets growing up and I blame my obsession on you. Thank you.

Jim—You introduced me to a world I never knew I'd be so fascinated about before we even met, and now here I am, writing a book on it that you wrote a forward in. Thank you.

Heidi, Jane, and Claire—You have all made impacts in my life far beyond what I could have discovered on my own. Thank you for being direct, challenging me, and being guides for me at different points in my life's biggest transitions.

Dylan—What a beautiful space you create for existence. Your passion for facilitating the practice of self care for both yourself and others is inspiring. Thank you for reminding us that showing up is the biggest step.

Index

A

activities, 25
architecture, 25, 97–101
archival pens, 14
awareness, 1–2

B

basic shapes, 118–120

C

character, 25
characteristics, 23–26
cognitive behavioral therapy
(CBT), 151
colors, 25
comfort, prompt, 132–133
completion, 137–143
coneflower, sketching, 107–113
creativity, 5
crosshatching, 83

D

dialectical behavioral therapy
(DBT), 152, 154
doughnuts, sketching, 102–107

E

emotion, evoking, 87–93
energy, 25. *See also* imperfection
excitement, prompt, 134
exercises
 characteristics, 121
 density, 84
 drawing shapes, 36
 emotional responses, 89–90
 gripping, 78
 one-point perspective, 52
 perspective, 50
 space, 73
 two-point perspective, 63
 expressive lines, 74–79

F

flowers, 107–113
focused breathing, 150
food, 102–107
framing, 67–79
 balcony plants, 72–73
 expressive lines, 74–79
 people, 70–71
 viewfinder, 68–69
frosting. See doughnuts

G

grip, 76–77

H

hatching, 83
heads, sketching, 116–117
horizon line, 41
horseshoes, 85
hot spot, 23

I

imperfection, 17–20
 characteristics, 23–24
 less is more, 29
 location, 27
 scenes, 30
 surroundings, 29
 waiting, 27

K

Kuthe, Riona, 9

L

learning, prompt, 135
less is more, 29
 phrase, 15–16
light source, 82
location, choosing, 27

M

mark-making, 83–85
materials, 13–16
meditation, 149–151
mental health. *See* meditation
mind, presence of, 141–145
mindfulness, 1–2, 142
 creating opportunities for, 20
 exercise in, 89–90
 meditation, 149
 sketching, 6–9
mistakes. *See* imperfection
mixed-media paper, 14
moods, sketching, 81–85

N

negative emotion, 88
negative emotions, 3–5

O

objects, 25
one-point perspective
 contrast, 49
 horizon line, 41
 identifying shapes, 43–47
 less is more, 48
 principles, 39–40
 vanishing point, 42

P

paper. *See* mixed-media paper
passion, sharing, 92–93
people, sketching
 basic shapes, 118–120
 building scene, 122–125
 heads, 116–17
pens. *See* archival pens
perspective, 38
 one-point, 39–51
 two-point, 52–63
 scale, 64–66
photography, 17–18
plants

balcony plants, 72–73
 flowers, 107–113
positive emotion, 88
progressive muscle relaxation, 151

R

rectangular stacks, 85
Richards, James, 6–8

S

scale, 64–66
scenes
 building, 122–125
 types of, 30
Scheinberger, Felix, 8
shadows, identifying, 82
shapes, identifying, 43–47
sketching, 6–9
 benefits, 10–12
 completion, 137–143
 evoking emotion, 87–93
 framing scenes, 67–79
 imperfection, 17–32
 materials, 13–16
 moods, 81–85
 people, 115–125
 prompts for, 127–135
 subject, 95–113
 techniques, 33–66

stippling, 84
STOP, 152–154
style, creating, 140
subjects, 95–96
 architecture, 97–101
 flowers, 107–13
 food, 102–7
surroundings, 29

T

techniques, 33–37
texture, 25
two-point perspective, 52–63

U

unknowing, 36

V

vanishing point, 42
viewfinder, 68–69

W

waiting, 27
weather, 25
Win, Ohn Mar, 9

About the Author

Peggy Dean is native to the Pacific Northwest and is a freelance artist with worldwide publications as a platform artist. Her lettering and illustrative designs have been nationally recognized, with a focus on modern calligraphy and line drawing, though her skills range vastly in the world of creativity. She is an author of several bestselling how-to books: *The Ultimate Brush Lettering Guide, Botanical Line Drawing*, and *Peggy Dean's Guide to Nature Drawing & Watercolor*. Peggy is an award-winning online instructor with a range of classes covering art techniques and business techniques. She also hosts an informational blog and maintains a popular instructional social media platform to inspire people to create. Peggy embraces natural elements in her everyday life, and it shows in her work, surrounding herself in greenery and botanicals. She is predominantly self-taught, which she proudly uses to assist others. She lives and works in Portland, Oregon.

Printed in China

SPRUCE BOOKS with colophon is a registered trademark of Penguin Random House LLC

26 25 24 23 22 9 8 7 6 5 4 3 2

Editor: Sharyn Rosart
Production editor: Jill Saginario
Designer: Alicia Terry

Library of Congress Cataloging-in-Publication Data
Names: Dean, Peggy (Illustrator) author.
Title: Mindful sketching : how to develop a drawing practice and embrace
the art of imperfection / Peggy Dean.
Description: Seattle, WA : Spruce Books, [2022] | Includes index. |
Identifiers: LCCN 2021038419 | ISBN 9781632174192 (paperback)
Subjects: LCSH: Drawing--Technique. | Drawing--Psychological aspects.
Classification: LCC NC730 .D425 2022 | DDC 741.2--dc23
LC record available at https://lccn.loc.gov/2021038419

ISBN: 978-1-63217-419-2

Sasquatch Books
1325 Fourth Avenue, Suite 1025
Seattle, WA 98101

SasquatchBooks.com

oh hey!

I'm Peggy.

I'm on a mission to help creatives release the need for perfection and instead, embrace the organic qualities that make our creative process come to life with unique personality.

Nobody can create exactly the same way that you do.
That's what makes you special.
That's what makes you YOU.

I'm...
- an artist
- an author
- an educator

...and I can help you be that, too

thepigeonletters.com
@thepigeonletters